REDBOURN
THROUGH TIME

REDBOURN

THROUGH TIME

Geoff Webb

AMBERLEY PUBLISHING

Also by Geoff Webb:

A Redbourn Commoner
The Character of Redbourn
Redbourn Reflections

First published 2008

Amberley Publishing Plc
Cirencester Road, Chalford,
Stroud, Gloucestershire, GL6 8PE

www.amberley-books.com

British Library Cataloguing in Publication Data.
A catalogue record for this book is available from the British Library.

ISBN 978 1 84868 128 6

Typesetting and Origination by Amberley Publishing.
Printed in Great Britain.

Introduction

Redbourn, like many country villages, was a community of characters where many people were related, even distantly, and I feel privileged to remember it as such. It was seldom necessary to lock our doors, and friends walked in knowing there would be a welcome – usually accompanied by a cup of tea. Favours were returned with no mention of payment, and a verbal promise was binding. Old photographs recall these memorable times, bringing a smile as we recall past events and occasions. Indeed this is another form of a book of remembrance.

In modern times the village has a different air about it, with people constantly coming and going in this world of instant transportation, and having to commute with their work and occupations. Such an environment, in some instances, makes lasting friendships difficult to maintain.

When taking the modern photographs, I was amazed how so many trees have altered the landscape, thus making some scenes hard to replicate. Having explained how the village has changed, Redbourn is still a special place to live.

Geoff Webb

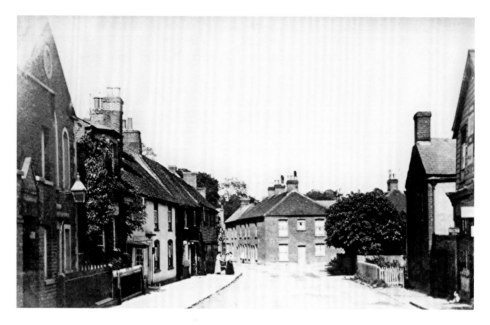

Fish Street

Fish Street (photograph *c.* 1900) used to be a sleepy byway leading from the High Street onto The Common. To the left is the Congregational Chapel which the Webb ancestors attended. As a young boy in the 1930s, I attended Sunday School here. Russell Harborough was the local jam factory owner, and was a leading light in the Chapel's early days. Opposite can be seen Amos Brewer's cobblers shop. He could discuss any subject, even with a mouthful of brads, and deficient hearing. He would mend a football, or replace studs in boots for a copper or two – sometimes not even that. Amos repaired horse harness, and his hand stitched leather sole on a shoe was a masterpiece – the work of a true craftsman. Sadly the cobbler's shop no longer hears its thud of Amos's hammer, but is a private home. The Chapel does, however, still hear the sound of worship. The outside façade has changed little, but the interior has had major renovations – a credit to its devoted congregation.

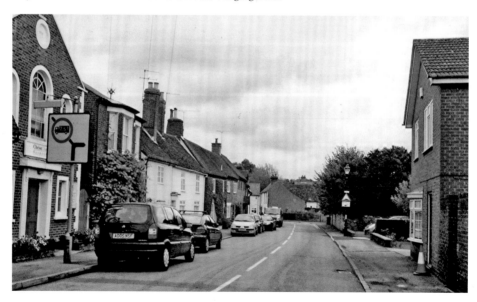

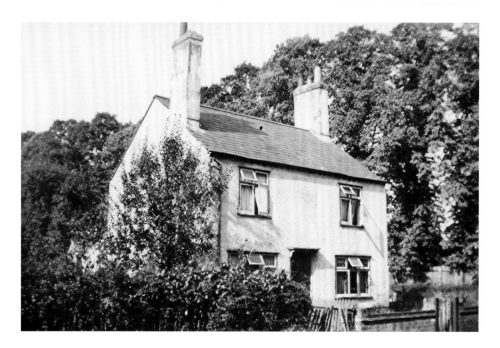

The Waggon & Horses

The Waggon & Horses (photo *c.* 1950) was situated on the Hemel Hempstead Road near the church. It was more of a 'beer house' than a pub, which meant the landlord had a licence to sell beer only through the front door. Just before 'The Waggon' ceased to be a 'beer house', around 1910, the last landlady, Elizabeth Sinfield, was a grim looking woman in a long black dress – a person who stood no nonsense. Her husband seemed to try to put right such a glum atmosphere with his chirpy personality. His nickname was 'Chummy', and he was a chimney sweep by trade. From 1910 the house became a private dwelling. Following World War 2 it, and the nearby row of four cottages known as 'The Camp', were demolished. In two small ponds behind the cottages we youngsters caught our newts. Today neat bungalows occupy the site with the churchyard over the back hedge.

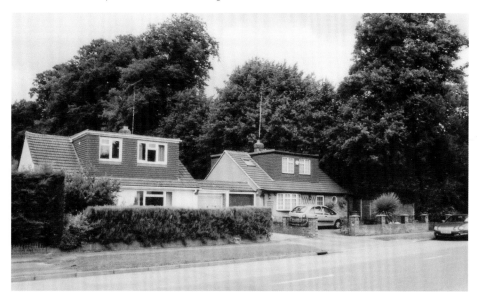

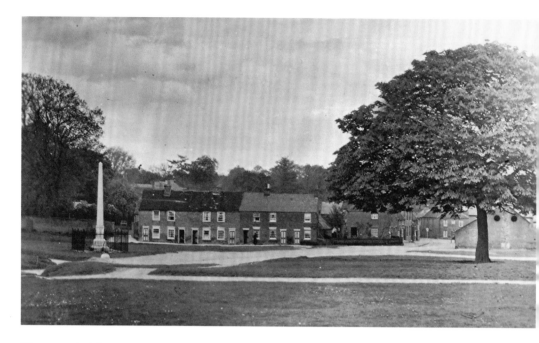

The top of Fish Street

The War Memorial and the top of Fish Street can be found at the South East corner of The Common (photo *c.* 1925). The Memorial was unveiled in 1923, and since then and up to the present day, Armistice Day is marked with a service, when friends and relatives of those whose names appear on the column gather to remember them. Handkerchiefs dab the odd tear – a sign of silent reverence. Each day a businessman, on his way to the station, would pause and raise his bowler hat to the memory of those brave people. The local gas works was built in 1861, but I do not remember signs of the gas holders in my young lifetime. The site of the old memorial has been extended, and the addition of a flag pole is most welcome. The cottages were condemned and replaced by bungalows for old folk.

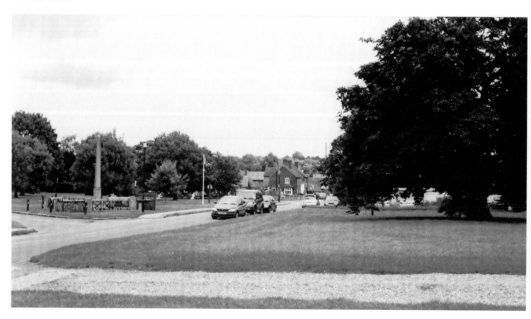

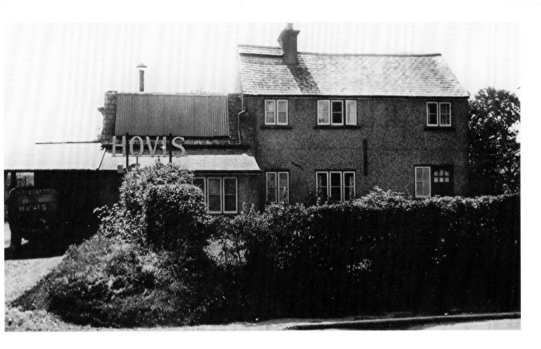

Statham's

This bakehouse (photo *c.* 1935) was the home of the Brooke family. Stan was a good tennis player and a member of the A.R.P. in World War 2. My father and uncle were also members, and with Saturday night as duty night, together with another warden, the three man team plus a young teenage 'runner' needed another one for a Solo school. Stan would come to make up the four, bringing a supply of cakes and meat pies to keep the 'runner' quiet through the night. Soon after the war, Sid Statham took over the bakehouse site with his garage. What a character he was. When asked about his health, he replied 'Another clean white shirt will see me out'. The Stathams were well known in the area, and very popular. The name of the new flats, Stathams Court, on the garage site opposite the church gates is a lasting tribute to Sid and his family. The village bypass is immediately behind them.

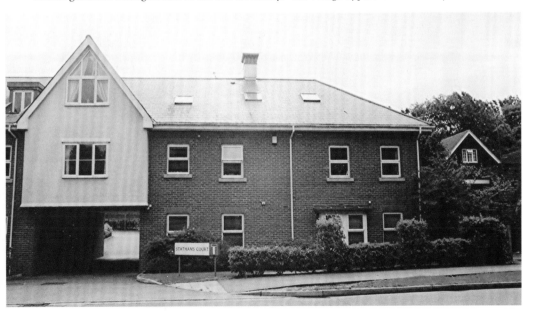

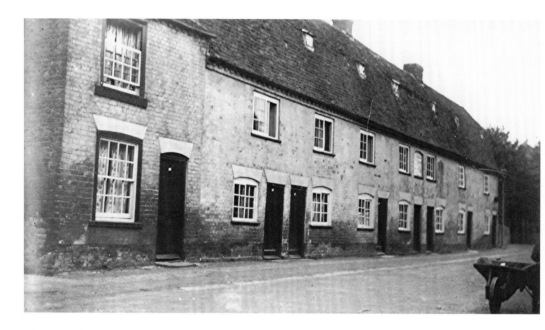

The Workhouse

This row of cottages (photo *c.* 1925) was the old Workhouse for the village, and with its mansard roof, provided accommodation for the poorer residents of the parish. They are situated at the end of Church End, next to the church gates. An old London evacuee, known affectionately as 'Gran' lived here, and when delivering her milk one Christmas Eve morning, she stood at the door in tears. On enquiring as to the cause, she pointed out that she could only manage sixpence (2 1/2p in today's currency) as a Christmas box for me. Such a gesture of genuine appreciation was very touching. Over the door of the last cottage can be seen a chimney sweep's brush – this was 'Chummy's home after moving from 'The Waggon & Horses', and a sign of his trade. In these modern times, home life is considerably more comfortable, which is reflected in this modern picture of the cottages.

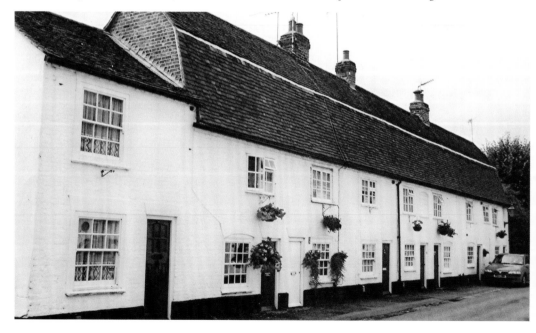

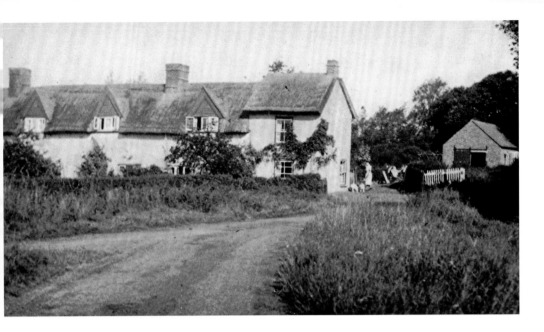

Mansdale Cottages

These two thatched cottages are situated at the west end of The Common. Teddy Dexter ran a dairy from the top one when this picture was taken in 1943. (There were three dairies in the village at that time). Flo, his wife, was a lovely lady, and could be seen with her bulldogs. To prove a point from the property deeds, Teddy would walk up and down a communal path in front of the cottages at 3.30 each morning – singing a hymn, after which he would set off on his rounds. I was told this story by the daughter of the family that lived in the bottom cottage. I did get the impression that she was not amused. In the back garden Jack, Teddy's son, kept an aviary of foreign birds – a golden pheasant is still vivid in my mind. Both cottages are now private homes with attractive gardens designed in the old cottage tradition.

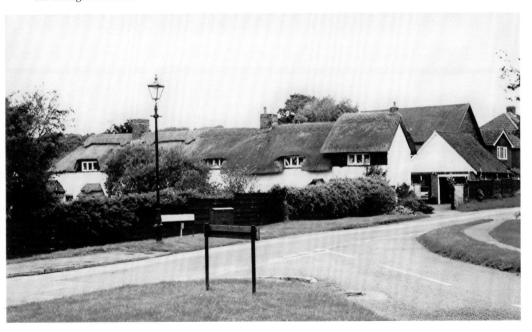

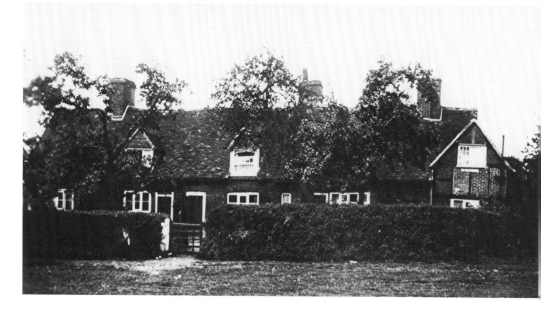

The Beesnest

The quaint row of old cottages was near the cricket ground, and home to several families of long standing in the village. Daniel Abbott, the shepherd, was one who lived here, but probably, the one who conjures up the most affectionate memories is Tom Pratt. Tom lived in the end one of the left, and he was a great benefactor to the Wesleyan Chapel (now the Methodist Church) on North Common. In the 1920s and '30s his horse and cart would transport the Sunday School youngsters to their annual picnic at Porridge Pot – fields to the north of Harpenden Lane. He would cut a boy's hair for a halfpenny! Tom also took in waifs and strays. Growing into adults, they were quick to accredit their existences to Tom's kindness. The row is now a private home with its undulating ridge in testimony to it's age.

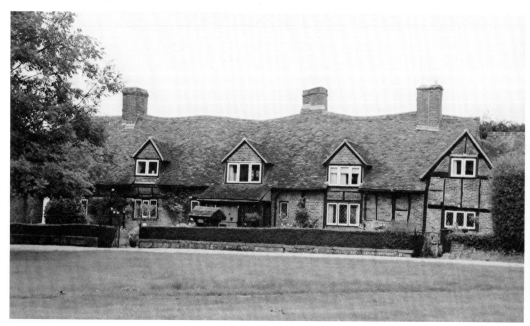

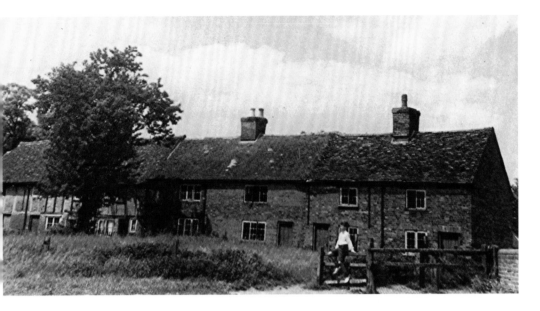

Snatchup Cottages

Snatchup Cottages were condemned when this photograph was taken in 1950. They had been home to a few very large families, but shortly they would disappear. The stile and farm gate to the right led into a field, known as Coopers Meadows, that stretched to Lybury Lane. Soon after this photo, the land provided houses on a road aptly named Snatchup, with another, Coopers Meadow. Snatchup cottages kept to the country traditions with a well in the front gardens to serve their needs. Before the row stood derelict, some London evacuees escaping from the Blitz, were happy to set up home there. I can remember watching the flood waters in 1947 rushing through the fields, emerging over halfway up the gate onto The Common. No scenes like these had ever been witnessed before in the village. The road in the modern picture is Snatchup leading into a housing estate, together with the Infants and Junior Schools. Old people's bungalows have replaced the cottages.

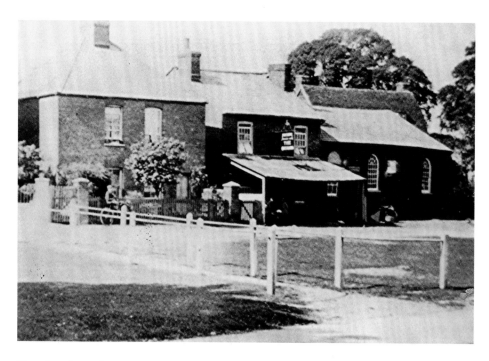

The Greyhound

The Greyhound Public House was one of the earliest in Redbourn and was found at North Common (photo *c.* 1908). The original house had been named 'The Ashes', but The Greyhound became one of the many pubs dotted around the village, most of which were in the High Street. The building on the right was the first Wesleyan Chapel in Redbourn, opened in 1836. With membership growing, it wasn't long before another chapel was built nearby. To the rear of these properties was a field known as Greyhound Meadow, and today is the home of the Boy Scouts, and a thriving tennis club. To the side are allotments, opened just after the Second World War. The old chapel was converted to a butcher's shop – his sausages were superb. Other shopkeepers have used it since. The black door led to a storage area.

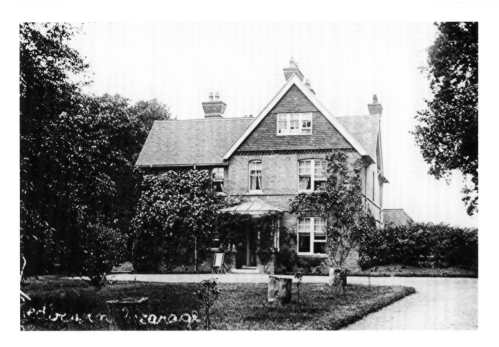

The Vicarage

To the left of the old vicarage was a paddock, where, with the arrival of the Reverend David Bickerton in 1942, the new vicar allowed the Scouts to camp. He followed the rather sterner and more serious Reverend Birkhead Berry. David Bickerton was more liberally minded, and encouraged the youth of the village with a fresh energy and enthusiasm. As a young Scout, I only attended camp once as it rained all night, and the 'elected' cook burnt the breakfast baked beans and sausages. I rolled up my damp bedding and rapidly returned home! The vicarage is now part of an attractive development next to St. Mary's Church and its graveyard. The house has been divided into flats, and has lost its serene setting, but not the many happy memories and connections with Redbourn.

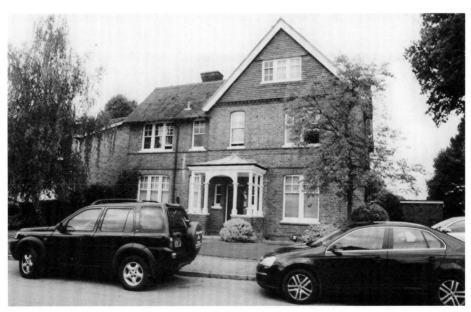

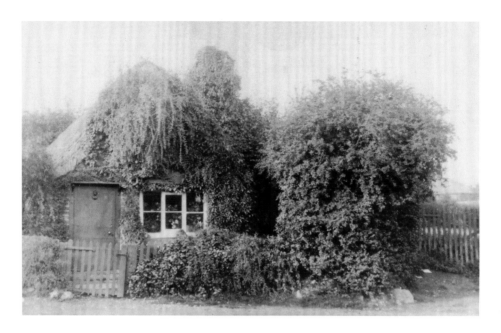

Sunshine Corner

This site is one of the oldest in the village, and shown here circa 1905. The ancient building was known as a 'cruck house' because the ends of its roof were assembled with two pieces of timber, with a curve near the top. Sometimes this roof shape was accomplished with one whole piece of timber, known as a 'cruck'. An elderly lady tells us of when her grandparents – the Powells – lived there, and how she visited them when she was a child. It was sited where Lamb Lane joins Crouch Hall Lane. The old house was demolished when the Powells vacated it in their closing years. A wooden building was erected in its place shortly after World War 2, where Jehovah Witnesses regularly worshipped. The name Sunshine Corner is reflected in the happy photographs of children at Christmas parties provided by the adults. Following significant renovation work, the successful Redbourn Players use it as their centre for meetings and rehearsals.

Lamb Lane

Lamb Lane looked like this around 1905, when the road was more of a track with barely a defined footpath. At this time horses and carts would have been the main vehicles to use the road. The first house was the old public house 'The Bell'. Behind it can be seen an opening that led into an open space with a pair of cottages – hence the name Bell Yard. In the 1930's I remember Richard 'Titchy' King living at the house when it was a private home. He was one of the old village footballers, and plied his trade as a chimney sweep as he pushed his little green barrow holding his brushes and rods to the next customer. In later years the house was treated with Snowcem, and became The White Cottage.

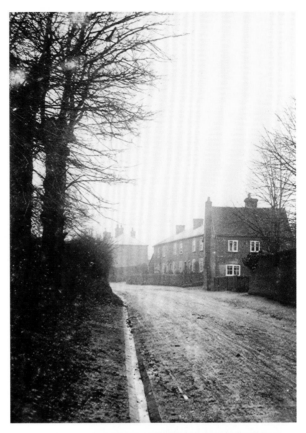

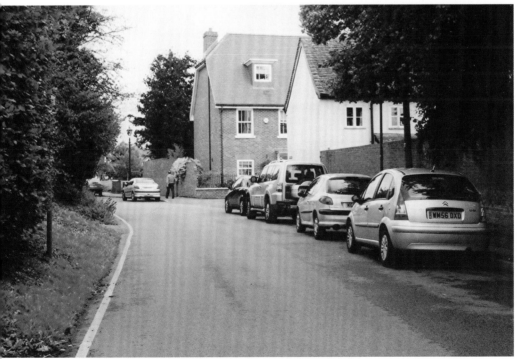

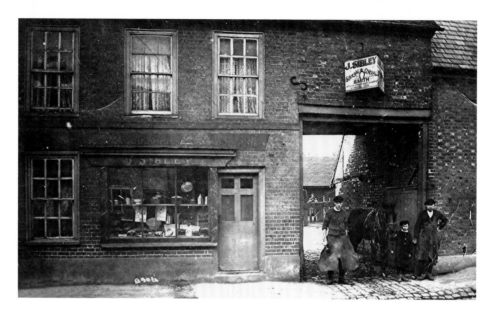

Blacksmiths

When our horses needed sets of shoes, it was fascinating to watch Bill gently handle these animals in the open fronted building adjoining his forge. Amid clouds of smoke and the smell of burnt hoof, the hot new shoe would be tested for size. This craftsman could also repair the ironwork of farm machinery as he had experienced tutoring from previous family members. Bill was the third and last generation of our village blacksmiths (photo *c.* 1922). The forge was the mecca for village gossip as characters met there to discuss the latest Redbourn news. One slightly upper class gentleman was waiting for his hunter, and enquired what family he had. Being told six boys, the toff smiled and asked what the secret was . Leaning on the vice 'Arpy' looked him straight in the eye and replied 'kippers for breakfast'! One side of the road now has wardened flats for the elderly, while the forge side has travelled to the other end of life's spectrum – a computer shop.

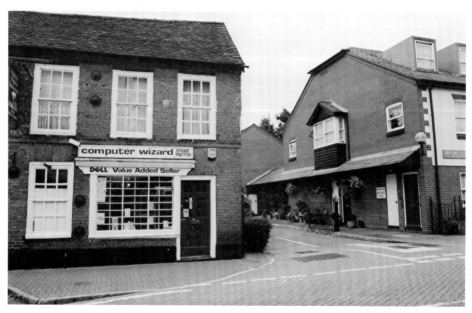

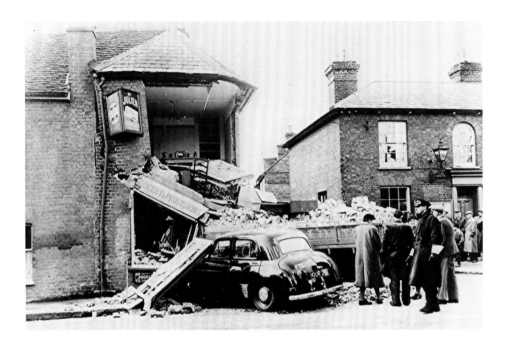

The Corner Shop

Redbourn High Street was part of the route to London used by lorries from the Bedfordshire brick fields. Some of these vehicles didn't make it, because their journey finished at the corner shop where Fish Street meets the southern end of the High Street. Remarkably the accidents seemed to involve only these brick lorries such as the one illustrated (*c.* 1950). Over the years it was a miracle that staff and customers escaped serious injury, although some did have frightening experiences. The lady wearing a long coat is Gertrude Peake, a local lady of high standing, and a generous benefactor to Redbourn. When the Law was called they were soon on the scene, because the Police Station was on the opposite corner. The Police Station was eventually demolished to afford a road widening scheme incorporating the Fish Street junction. I'm pleased to say the corner shop still carries that same customer service of friendship.

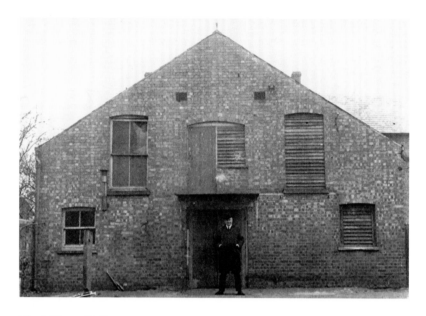

The Village Hall

Shortly after the First World War the original hat factory was purchased by Redbourn Parish Council, and was known as the Public Hall. It was soon after World War 2 that the name was altered to the Village Hall. At about this time John Heather (photo 1949) introduced himself to the village when providing film shows for the youngsters on Friday nights. It became so popular that two sittings were needed to accommodate the enthusiasts. John was a quiet, gentle man with a generous nature. Later information showed his good work in hospitals and other deserving causes. Regularly John's calm nature was sorely tested on film nights, as the excited children's behaviour brought threats of turning off the projector – I can never remember this being carried out. This popular venue is now home to many functions and organisations. Today the Hall's appearance is a tasteful illustration of a diligent Parish Council and Village Hall Management Committee.

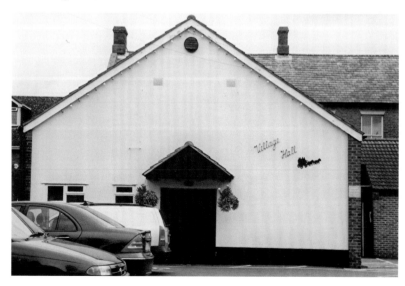

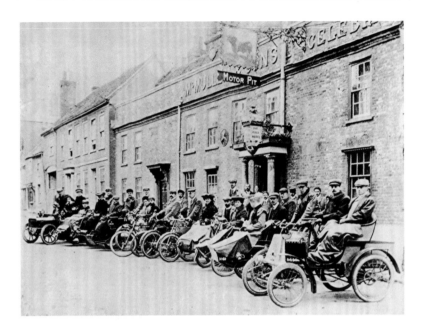

The Bull

Originally the Bull Hotel (picture *c.* 1904) was a regular stopping place for the Royal Mail coaches plying between London and the North. It provided accommodation for the travellers, and stabling for the horses. A lad would stand in the High Street and shout 'Up'ards' or 'Down'ards'depending on which way the coach was approaching. The picture was taken on the day McMullens Brewery opened its new establishment. Mr. & Mrs. Davenport stand in the doorway as new landlords. Soon after, the Bull Hotel was the start and finish of a national motor cycle time trial run to Stony Stratford and back, for the Albert Brown Trophy. In accordance with properties of ancient origins, ghost stories abound concerning the Bull Inn, as it was later named. People that have stayed there, or even lived there in recent times give convincing accounts of occult sightings. With a changed façade, McMullens still provide a comfortable hostelry.

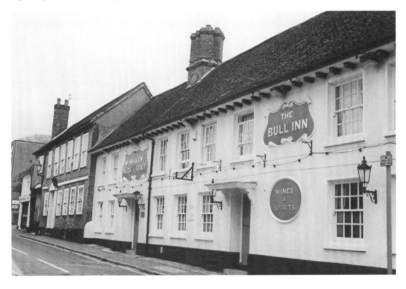

Dr Totton's

The imposing home (photo *c.* 1920) of Dr. Jurin Totton was in keeping with the doctor's stature. This big upright figure walked with a slow military bearing, and his slightly large head did nothing to allay a quite overbearing nature. He held his surgery in a huge study, where, on a winter's night he just had a table lamp on his desk, with the rest of the room in darkness. Large old portraits in heavy frames were just discernable through the gloom. He seemed to suffer children with obvious difficulty, but was prepared to spend more time with adults. I've heard my grandparents tell of his visits to them, and how he would sit contentedly talking for a long time. He mixed his own potions, which tiny Nellie Lee would potter around the village to deliver. The doctor came to the village in the mid 1920s with impressive medical credentials, and the general opinion of his expertise confirmed such references. The home has been converted into offices in the past years, with the garden forming a housing development named Totton Mews.

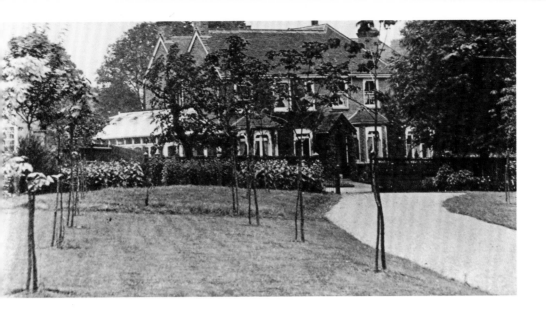

Cumberland Cottage

The owner of this lovely house, seen here in the 1920s, was Mr. Frederick Hall. It is at the bottom of Crown Street, a quiet byroad from the High Street. An avenue of horse chestnut trees led from the front door to Waterend Lane, at the end of which was a coach house. This avenue proved a 'conker haven' for little boys to supplement their armaments for future contests. In the 1930s Mr. Hall sold some of his extensive grounds to provide housing at Harpenden Lane and Ver Road. A more recent owner, Gordon Hosking, sold off more ground for other developments. Probably Mr. Hosking's greatest legacy to the village was to provide missionary accommodation on the ground in front of his home. The loss of the horse chestnut trees was a small price to pay for a gesture of kindness that proved a tremendous benefit for a dedicated body of people. The present day building has been split up into separate homes, plus other extensions making it still an impressive edifice.

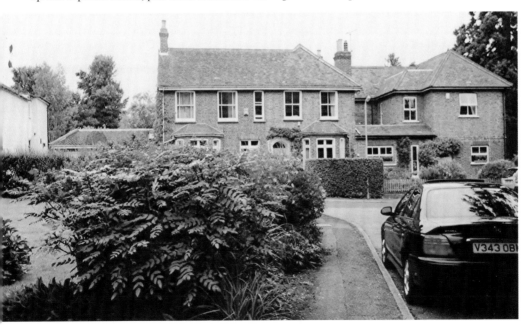

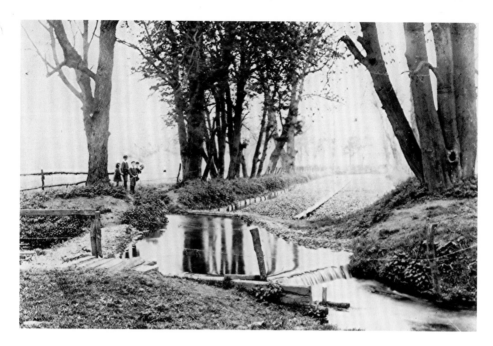

Waterend Lane

Another road leading from the High Street is Waterend Lane, aptly named because the River Ver crosses it at a lower point. Gran Webb's father was Thomas Sansom who moved his family from Oxfordshire to Redbourn in 1866, and lived at Ver House, near the bottom of the High Street. With his knowledge of watercress growing, he started an extensive cress industry in the area on the Ver, but when quite aged he set up two of his sons in businesses at Croxley Green and Whitwell, while the third carried on the Redbourn business. The watercress was picked, baled and packed into woven 'skips'or 'chips' and transported to the local railway station by horse and cart, to be finally sold at the London markets. The cress beds at Waterend Lane looked like this in the early 1900s, and bordered the grounds at the rear of Redbourn House. Although more enclosed, there is still a good flow on the Ver, but sadly no cress.

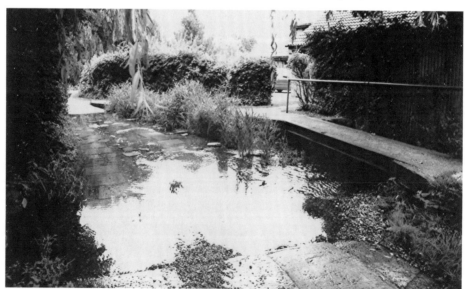

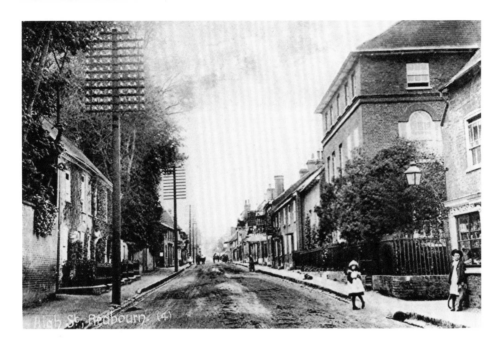

The Red House

It is plain when comparing the two photographs that where Waterend Lane joined the High Street, very little has changed after some 100 years. The Harborough family at the little corner shop was very popular, and sold stationery and toys. Harry was an ex Sunday School teacher at the Congregational Chapel in Fish Street, and an uncle has told how he loved to go to Sunday School there because "Mr. Harborough told the class stories of his experiences in the First World War." The Red House was the home of Lady Charlotte Glamis when she moved from Redbourn House after it became too large for her. I can remember the White family being in residence, when the local gentry in the 1930s had servants. In more recent times a company bought the property and converted it into offices, and when wanting to expand, it acquired Dr. Totton's house opposite that stood empty at the time.

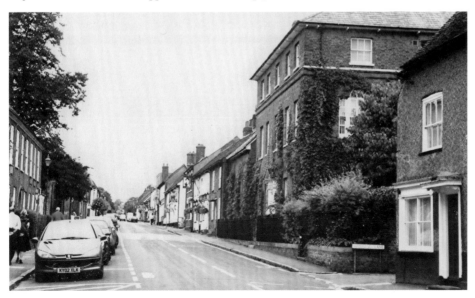

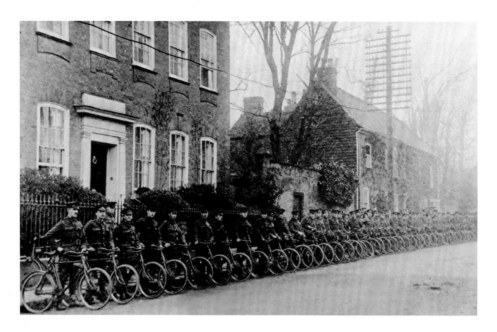

The Priory

World War 1 saw the 1st London Bicycle Battalion pass through the village, after having its picture taken outside The Priory. The house has a long history, chequered with colourful families. The Brooke's were connected to the Brookes of Sarawak. It was reported that a daughter proved difficult to monitor, because her wandering personality linked her with Harry Roy, a popular band leader of the 1930s. Early one morning the local policeman apprehended a man climbing over the gates into the High Street – it was Harry. True or not it makes a nice story! In my day the Maude's lived there, a family with two girls and a boy. When Peter was on holiday from Eton he would play cricket on The Common with we boys. He gave me a cricket book, 'The Match of the Season' – I still have it signed with his name. He lost his life in an air disaster in 1957 – a great loss. Once again, the house has been converted into offices.

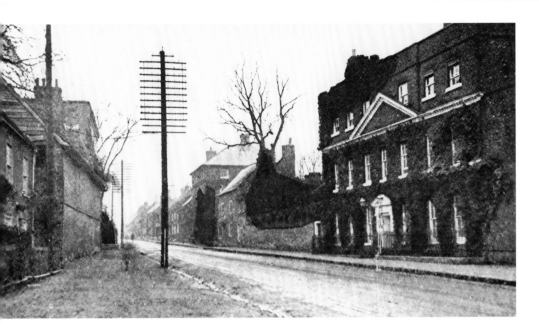

Redbourn House

Near the bottom of the High Street was Redbourn House (photo *c.* 1925), an impressive Georgian building that became the home of a member of the Bowes-Lyon family. Geoffrey was the last owner – resident in 1935. At the rear, the extensive grounds included a lake and ran down to the River Ver. Mrs. Scott lived at the house in the early 1900s and before World War I encouraged local singers and musicians to hone their talents to levels where concerts were held. Photographs prove that some were performed in the gardens. During World War II the house was occupied by families evacuated from Plymouth, following the city's blitz by the Germans. The men of the families were employed by the printers Fisher Knight. Eventually the property was demolished and in the 1960s Gertrude Peake Place was built – an old peoples wardened accommodation. The name is a fitting memorial to a past village benefactor, a lady revered by all.

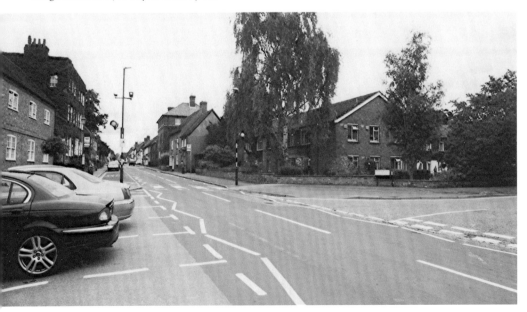

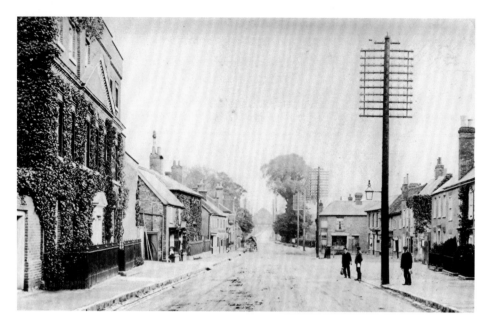

Bottom of the High Street

Looking south at the bottom of the High Street (photo *c.* 1910) shows us Redbourn House on the left, and a little grocery shop next door. Mr. Blunt was the village's popular Scout leader in the 1930s, and would serve in the shop with his pleasant chat, quite typical of the times. His wife followed the same principles, thus giving the shop an air of welcome. In the slightly confined space some villagers thought the butter was a little too close to the paraffin tank, but this was par for the course. Next door was the ivy covered Ver House, home of my grandmother's father, the watercress grower, Thomas Sansom. When an uncle owned the property, I can remember 'Murder' being played at Christmas parties, a terrifying experience in the dark, with creaking floor boards. Although Redbourn House has disappeared, the shop still serves groceries, and Ver House is clean faced.

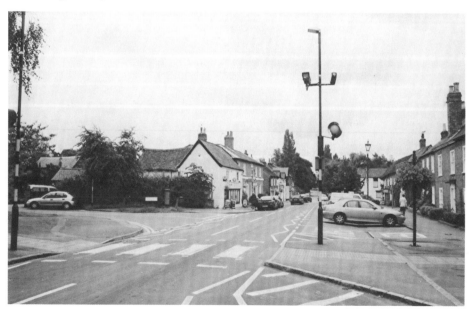

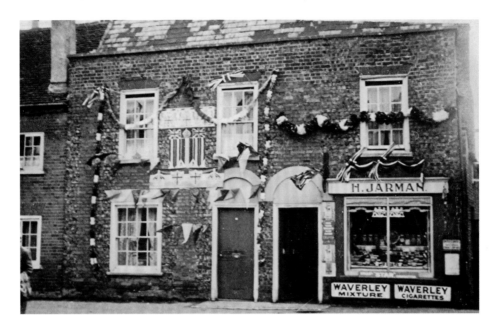

Jarman's Shop

In May 1935 the nation celebrated in style the Silver Jubilee of King George V and Queen Mary. Jarman's shop, opposite Redbourn House, was a typical example of general thanksgiving for the popular monarch. The shop obviously sold tobacco and sweets, as can be seen by the row of sweet jars in the window. Mrs. Jarman was a quiet homely lady, and always seemed pleased to see you. The opening at the side led, and still does, to Lavender Cottage, once a property belonging to the Bowes-Lyon family. At the rear of the shop can be seen an ancient looking addition that was once, in the late 1800s, bakehouse run by my ancestors. As can be seen in the modern picture, the property has retained much of its former appearance, and as a hairdressers, the proprietors are still tending to the needs of the Redbourn residents.

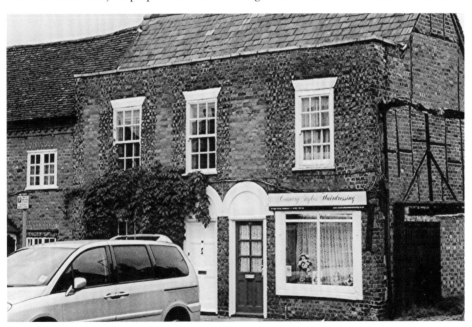

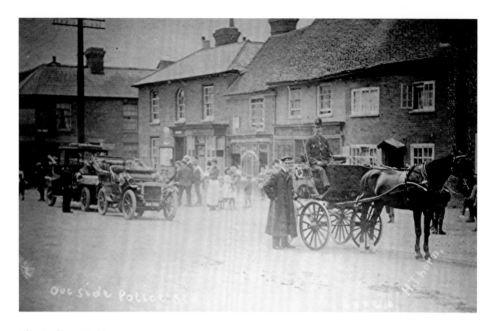

The Police Station

Where Fish Street joined the High Street, it would have looked like this circa 1910. The dominant building is the Police Station, with its large window and notice board. The cells were at the rear, where some locals experienced spending a night. Probably one of the 'regulars' was Jimmy 'Rougheye', a poacher who only appeared at night. It would seem he often spent time at the Station when apprehended. This nocturnal character had a warmer side, as he would provide a dead hare for a war widow with a large family – she would find it on the backdoor step in the morning, when it got light. There was no note, but she knew who had left it. Although, in the photograph, it was obviously an event connected with the police, local interest is centred on the car, a rare sight at that time. The entrance to Fish Street was widened following the demolition of the Police Station.

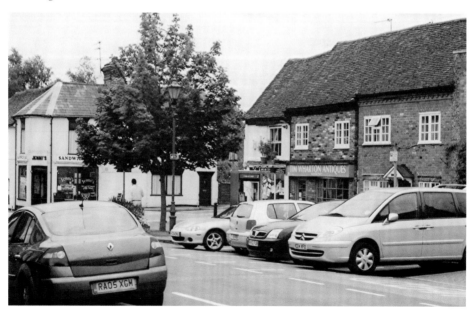

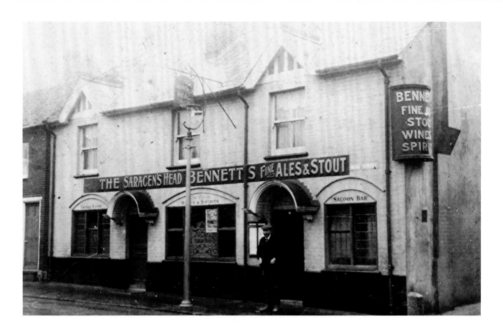

The Saracen's Head

The Saracen's Head, seen here circa 1935, dates back to the early 1600s, with an obvious reference to the Crusades. Much later this hostelry was well known for its refreshments when catering for large groups of cyclists from various clubs. Landlord Bob Matthews stands outside the pub, probably waiting to open. Next door was a small shop where Bob exercised his other expertise. He was noted for rope making, and when the War Memorial was unveiled in 1923, the Parish Council was worried right up to the last moment because the rope attached to the flag would not release the veiling Union Jack. Bob, a Parish Council member at the time, worked in his shop to improvise a rope that saved the day. The Saracen's Head was a busy pub until the last few years when it stood neglected and empty – a sad demise for such a local landmark. Recently the old public house has had a smart renovation, and the beautician now caters for the local ladies.

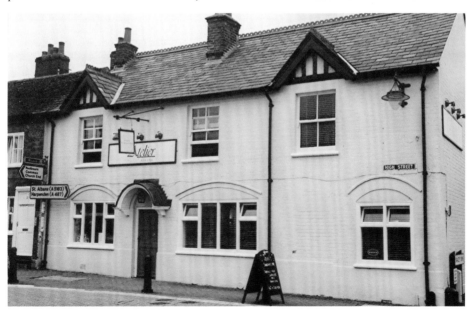

The Tanyard

The entrance to the Tanyard (photo 1899) was next to the Saracen's Head public house. Tanning the fresh animal skins was not a very pleasant job, as can be seen by mens' working clothes and leather aprons. When the temperature in hot summer days rose, so did the smell from the yard as it seeped all over the village, enforcing nearby doors and windows to be kept shut. This fusion with the sickly smells of boiling jam from Russell Harborough's jam factory next door was a test for weak stomachs – all part of the pleasure of living in the country! Tom Piper was the owner, and provided employment for locals for a number of years. In the picture the tanned hides have been bundled and wrapped ready for transporting to the local railway station, on the station's own horse and cart. Recently the area has been developed into attractive housing, with not a sign of its previous occupants.

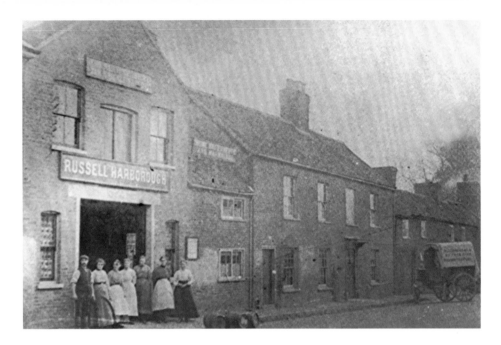

Russell Harborough's Jam Factory

Russell Harborough started his jam factory next to his home at the bottom of the High Street near the end of the nineteenth century, (photo *c.* 1895). When neighbouring cottages were demolished, he soon extended his premises. The factory provided employment for many locals over the following years, until after the Second World War. Among workers in the picture are Jim Dayton on the left, and Amy Catlin third from the right. In the 1920s and '30s Mr. Harborough would buy crops from the fruit fields, and some of his workers would act as pickers. Mr. Harborough was a devout member of the Congregational Chapel in Fish Street, and an old photograph of the graveyard shows his impressive headstone very dominant. Most of the stones have been moved to the side, but Mr. Harborough's remains. New work units have now replaced the factory – the village is no longer permeated with the sickly smell of boiling jam and marmalade.

The Heath

This comfortable home (photo 1918) stands in its own grounds, including copious outbuildings and a tennis court. It became the home of the Peake family when they moved from Cumberland House upon the death of the father, Robert Cecil Peake, in 1933. One of the large outbuildings was used as an A.R.P. post during the Second World War. The wailing siren was positioned in a nearly fir tree, and caused heart tremors for the locals when activated in the war's first years. My father and uncle went on duty at the post on Saturday nights, and left at daybreak to start the milk rounds. Staying awake was made easier when a solo school was made up. On a May night in 1941 these card players stood by the front gates to watch the glow in the sky over London as the docks burned in the Blitz. The latest occupants experience more peaceful times.

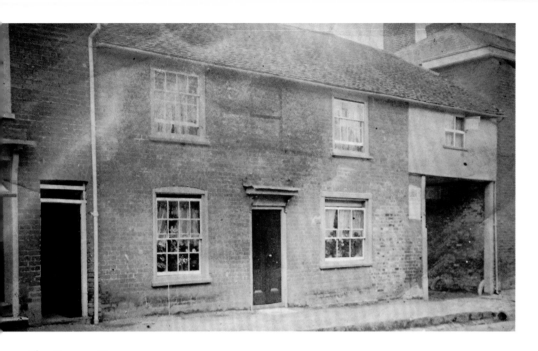

The Brewer House

This old house was always adjoined to the Post Office and the Fellowes were one of its earliest families. Amos Brewer, the village cobbler followed, and raised several children there. This family became a part of village life with contacts in many facets of sport and work. With the extensive residence of the Post Office and the Draper's home next door, these three homes all had loft spaces, and it was common knowledge how one could walk all the way along to the arch at Crown Street, Open lofts like these in rows of cottages and houses were not unusual at that time. The Italian restaurant of present times is superb, but memory recalls the 1950s when The Copper Kettle with Mrs. Wilkinson's mixed grills followed by knickerbocker glory was a youngster's dream. The lady's home cooking was unforgettable, especially by the choristers and friends who met there after church service on a Sunday evening.

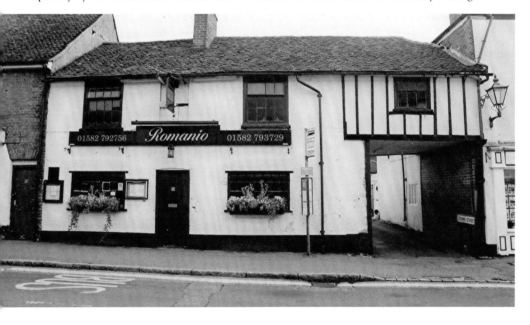

Goffy Wilson's

In 1950, Arthur 'Goffy' Wilson's barber shop stood empty and forlorn, but what stories it could have told, as neighbours Gordon and Doreen Bandy could verify. Youngsters dreaded the visit as the aged barber cropped their hair 'pudding-basin' style, and when finished would batter their heads with two pieces of bare wood that once were brushes with bristles. On one of my few visits, I remember seeing framed cigarette cards of sportsmen, but you could only see outlines of the heads through the nicotine stain. One old local recalled for me how 'Goffy', on a gloomy winter afternoon, would only turn on the gas light to give you your change! Another friend's mother gave him a penny to go to Mr. Wilson's shop, but the astute lad ran up the Common to Mr. Pratt's, who only charged a halfpenny – a halfpenny in the sweet shop went a long way then! Goffy's emporium has since been a cake shop and greengrocers, but never so interesting.

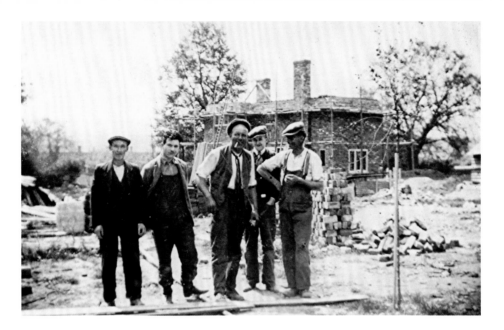

Crouch Hall Gardens

Crouch Hall Gardens links Bettespol Meadows to Crouch Hall Lane. All of this land was owned by William Walker, whose daughter, May, was a manager for this family building project. Mr. Walker also owned the blacksmith and coach builders yard that would have been found at the rear of the garage at the top of the High Street. An old picture taken around 1914 shows a group holding a fractious horse to be shod. Edwin Millard is one, while a young Arthur 'Bolly' Belshaw controls the horse's head. The photographed gang of workers were employed by May Walker when in the process of building Crouch Hall Gardens, *c.* 1934. Arthur Belshaw, in the centre, was the foreman with Arthur Archer to the right. The High Street garage was run by May Walker's brother, Stanley, more affectionately known as 'Tot'. Behind the garage during the Second World War was the Fire Brigade Station.

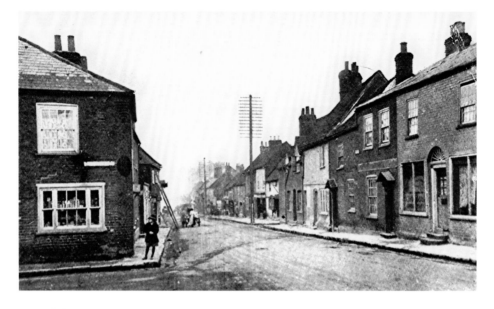

Top of the High Street – Harpenden Lane

In the 1930s this little shop on the corner of Harpenden Lane was owned by the Halsey family – they were from local stock. Soon after World War 2 the Beesley's arrived to take over the shop. This amiable family soon settled in to make many friends with pleasant shop manners. Just recently, daughter Helen, now residing in Australia, sent me several family photographs, but also included was a copy of the picture from the front of the Evening News dated Thursday, 30 December, 1948. Shortly after Christmas, it would appear, disaster struck in the form of a brick lorry out of control, careering down the hill towards the village from Dunstable. Trying to steer towards a field, the driver couldn't miss ricocheting from a telephone pole and going straight into the shop. The family of five, including a nine month old baby, escaped unscathed, but the brave driver was taken to hospital. The shop is now a private home, and its outlook a little more attractive, and safer.

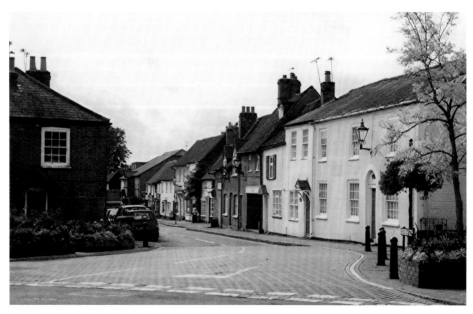

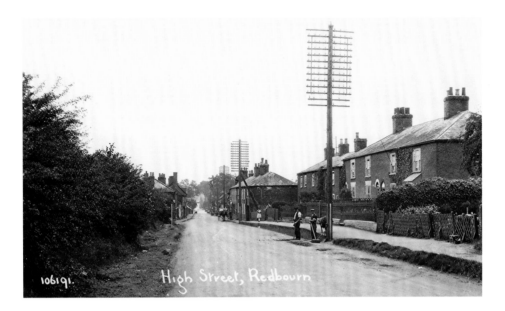

High Street, Redbourn
106191.

North Place

The topmost cottages of the High Street, on the Dunstable Road, were known as North Place. They looked onto a home meadow next to Scout Farm. At one period, Redbourn Football Club played its matches here. The house with the white arch (photo late 1930s) was where the Nunn family lived. Two sons, Geoff and 'Snowy' were strapping lads, and both served in the Royal Marines. For many years 'Snowy' was a notorious centre-half in the local football team – few centre forwards passed him. Wally, the father was a diminutive little chap with a likeable nature. The crows feet at the corners of his eyes gave the appearance that he was always smiling. During the Second World War he worked on the platform at St. Pancras, where he often met Redbourn boys and girls when they passed through the station, either coming off or going on leave. A quick cup of tea sufficed while catching up on local news.

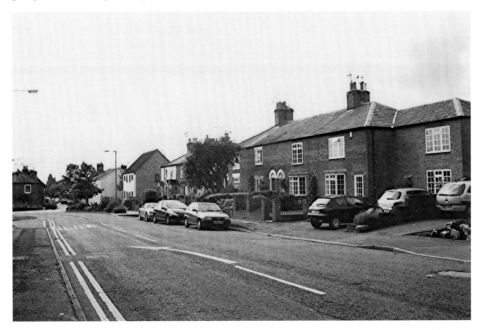

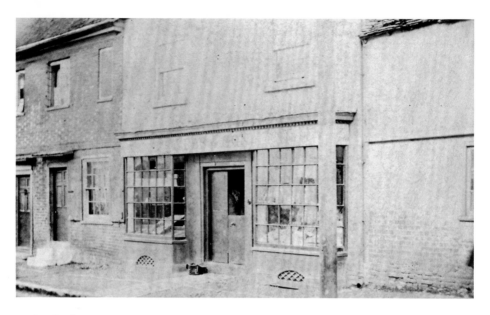

Halsey's Shop

This shop, at the top of the High Street, *c.* 1900, was the family home of my paternal
grandparents. Granddad was a corn chandler and had dealings with many farmers for their
seed orders. Following the old couple was Uncle Bert, my mother's brother, who sold sweets,
cigarettes and pipe tobacco. Bert was one of our milk roundsmen in the morning, taking over
from his wife in the shop at lunchtime. He was one of life's natural comics, so much so, in fact,
that he belonged to the village's Concert Party in the 1930s. His humourous turns were loudly
acclaimed by the villagers when concerts were put on at the Public Hall – his monologues and
songs, such as Burlington Bertie and The Old Soldier were truly memorable. The Concert Party
held its rehearsals in the front room at the farm, with Dad accompanying all the performers on
the piano. As a toddler I remember listening to the laughter as Mum bathed me in a tin bath in
front of the kitchen fire. Until recently, the shop has been a Saddlery.

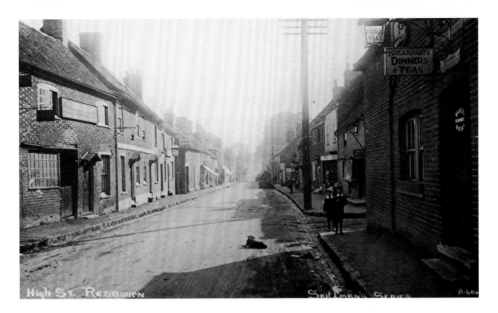

Top of the High Street

What a change! When this photograph was taken circa 1915, the High Street was quite deserted – note how the dog was quite safe lying in the road. The first property on the left side was Walker's coach building and blacksmith premises. Lower can be seen The Red Lion Public House where Jack Statham was landlord, and raised a large family there. In the 1930s his son, Sidney, was to prove one of the best goalkeepers Redbourn ever had. Later Charlie Green was a popular publican, with his snooker room upstairs. The Prince's Head Public House on the right was on the corner of Lamb Lane, and was a popular hostelry. In latter years it was converted into a greengrocers shop run by Ted Draper, a member of a prominent local family that catered for the villagers needs for many years. Even with a bypass, the traffic in the High Street can still be considerable, as can be seen in the modern picture – the Red Lion is now renamed The Bell and Shears.

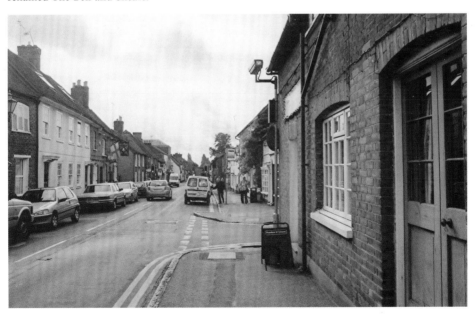

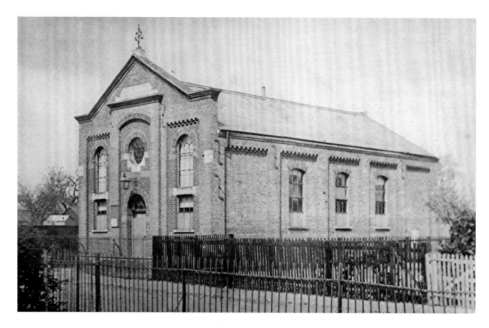

The Tabernacle Chapel

Crown Street is a quiet road leading from the High Street, and around 1910, when this photograph was taken, the Tabernacle Chapel was a large solidly built edifice that stood near the top. It was a branch of the Methodist following that attended services there, such families as the Pecks, Brewers, Holts and Pratts. An anniversary photograph, taken around the same time, shows a mixture of Victorian adults and pensive children, all dressed in their Sunday best attires. Ted Peck, a stern looking gentleman holding the lapel of his jacket; his little girls in their wide brimmed hats, and the boys with high buttoned boots. The ladies also wear very fetching hats of the same style. Mr. Osborne, the chapel caretaker, stands to the side, his full chin whiskers all white and fluffy. The chapel was demolished in the 1950s, and a private home erected on the site.

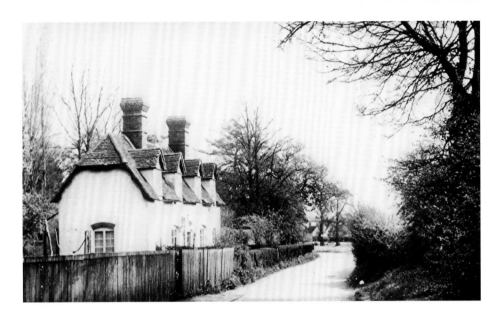

Cottages in Lybury Lane

Where Lybury Lane emerges on to the Common, there stand two cottages known as Heath Cottages. The old picture, *c.* 1930, shows a tranquil road, and with the cottages semi-detached, the two families pursued lives of close friendship, quite typical of a village existence. I remember them so well, because two more sociable families it was difficult to find. George Hooper and his family lived in the nearest one. In the garden was a large aviary where George bred Yorkshire Border canaries – his results reflected by the cups he won at cagebird shows. Next door was Peter Jackson, a quiet man with a friendly smile, and an ever present pipe that gave off a pleasant aroma of tobacco. Peter was a natural with a gun under his arm, a noted crackshot at the local shoots. To sit with him when watching cricket in the sunshine on the nearby Common, you would never imagine he was a sniper in World War I. The cottages have been extended, and are now close to other attractive homes.

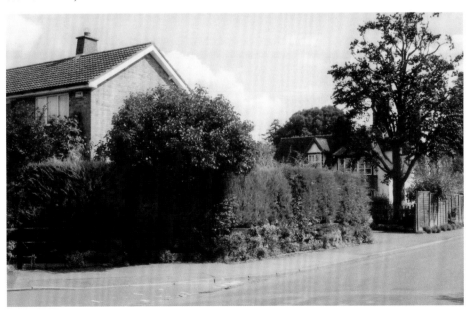

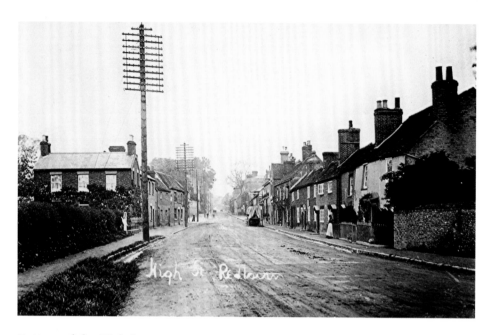

Bottom of the High Street

This picture, *c.* 1910, shows the bottom of the High Street looking north. Telegraph poles dominated the pavements, and were connected to the exchange at the Millard's home near the Bull Hotel in the middle of the High Street. Daughter Hilda was the operator, and seemed to know all the local news before anyone else! This harmless soul was my Sunday School teacher. The cottages to the right were condemned and demolished, thus providing the ground for Russell Harborough to build his jam factory. Progressing from the manufacture of sweets, Mr. Harborough expanded his industry to jam and marmalade making. On hot summer days the smell of these boiling preserves seemed to blanket the whole village. By the second telegraph pole can just be seen the sign of the Railway Inn public house, where the old Boer War veteran, Bill Mills, was landlord at this time. Later I remember Mr. & Mrs. Len East, before and during the Second World War, being very popular custodians. Modern industrial units occupy the factory site today.

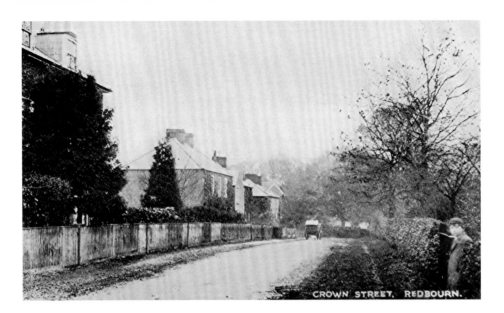

CROWN STREET, REDBOURN.

Crown Street

Crown Street was a cul-de-sac off the High Street, *c.* 1910. It was a road of considerable note in Redbourn, mainly because of the important people who lived there. They were residents Captain Douglas Bassett, a man of military bearing, and a Home Guard officer in the Second World War. At the bottom, just the gable of Cumberland Cottage is seen – the home of Frederick Hall, who owned most of the surrounding land that was to become Harpenden Lane and Ver Road. Coming up to the house with three bedroom windows, we would have found Ethel and May Piper. They lived in part of that building, and to their front room Redbourn ladies came to choose from the numerous wools for their knitting. Sidney Dimmock resided in the house on the left. He was a business man who played golf, drove a big Humber car, smoked cigars and had a glass eye! Some of these homes have been extended, and face more modern developments.

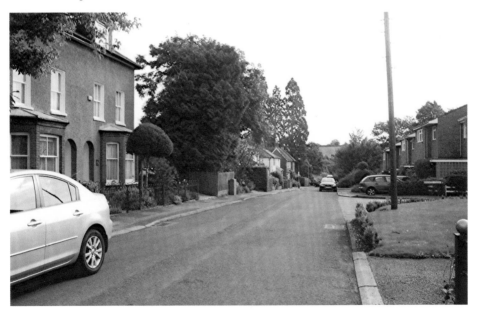

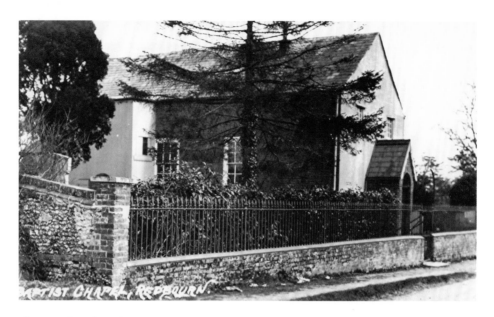

The Baptist Chapel (Mount Zion)

The Mount Zion Chapel at Lybury Lane was originally a Baptist Chapel. Members included the Pipers, Marshall and Rolts, with Mr. Aldworth as a Sunday School leader in the 1920s. May and Ethel Piper were teachers at that time, and the success of the youngsters singing skills was measured by the number of district competitions they won. So many and so regular, in fact, that they were asked not to enter! Around 1970 the Chapel became unsafe, and proved too expensive to repair. Negotiations with the generous Mrs. Gwennie Page (Russell Harborough's daughter) resulted in the congregation being offered the Congregational Chapel in Fish Street in which to continue its services. The sorry Mount Zion Chapel was taken over by a church organ repairer, Saxon Aldred, who for several years carried out his specialised work there. A few years ago the building was sold to a private buyer, who built the attractive home seen in the modern picture. To enable him to achieve this he had to finance the disinterment of stones and remains from the graveyard, and their movement to other cemeteries at Harpenden and our local St. Mary's Church.

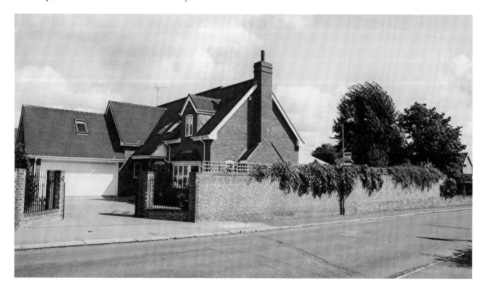

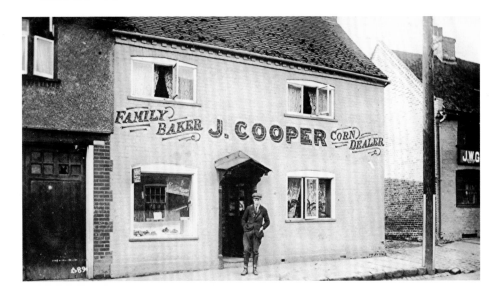

Cooper's Bakery

Mr. & Mrs. Frank Cooper's High Street bakery shop was next to the Queen Victoria pub, and opposite the Post Office. In his younger days, Frank was a noted athlete and swimmer in the district. Their son Jack is seen standing at the shop door, *c.* 1914, and he carried on the business following the death of his father, when living with his mother. Unfortunately, Jack had a speech impediment – his stuttering often causing difficulties. Acting as an A.R.P. warden in World War 2, Jack was on patrol one dark night, and challenged an approaching cyclist. "Halt! Who goes the....re? Ff..riend or foe? When the cyclist didn't stop, Jack, in desperation, threw his walking stick at him, only for it to stick in the front wheel, causing the cyclist to somersault over the handlebars. "I'll give you friend or foe if I catch you", he shouted. Luckily he didn't. At Christmas time Jack's huge ovens cooked joints and turkeys for the locals. Collecting ours one year, we asked him which was his. "N..one. We shall have our usual bubble and squ...eak" he stuttered. The premises has been replaced by a hairdresser and florist.

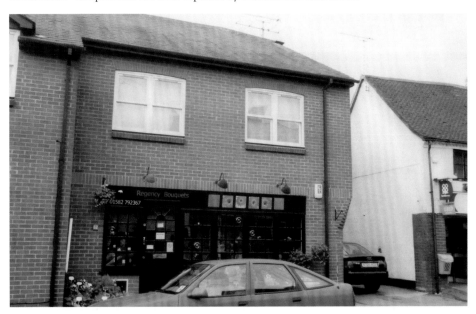

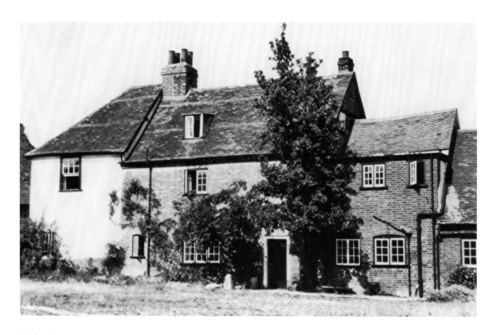

Fish Street Farm

The rear of Fish Street Farm has changed very little in the last fifty years, but it could tell many a story. Opposite used to stand a large black barn, next to the milking parlour. It was from this parlour we used to pick up the milk each morning and tea time in the 1930s and '40s. Not being far away, we travelled through the back fields by horse and milk float to reach the farm. Close to the milking parlour stood two huge walnut trees, which proved irresistible targets for local lads, who threw stones up to knock down the nuts. Either Mr. Vise the farmer, or Mr. Elsom, a farm worker, had to be avoided if possible. If not, youngsters hid their brown-stained hands deep into their pockets when denying any wrong doing. Mr. Vise, unfortunately, had no roof to his mouth, hence his knickname "Snorter". His son, Bob, grew watercress, and was a bowls stalwart in the area.

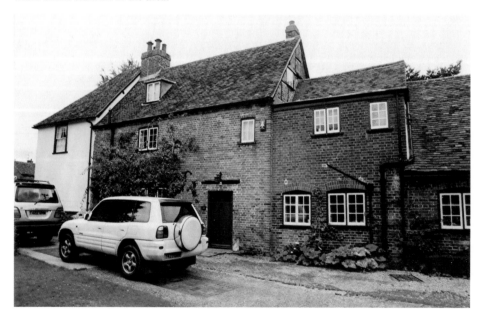

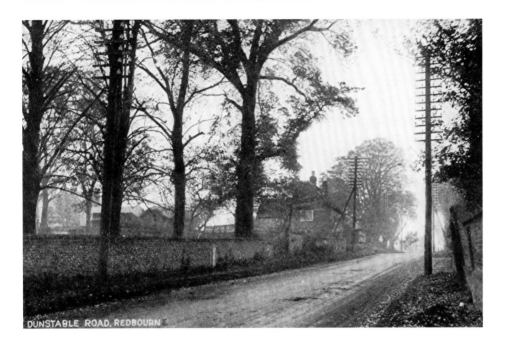

DUNSTABLE ROAD, REDBOURN

Bylands

Leaving the village to the north, via Dunstable Road up to Bylands, it would have looked like this in the late 1920s. Earlier, Colonel Christian de Falbe and his wife lived there. The Colonel was the son of the Danish Ambassador, who resided in London. The farm was noted for its herd of pedigree Jersey cows. Edna Dunning's father, Henry, came from Lincoln as gardener at the house. Following the tragic death of the Colonel in a train accident in France in 1924, the area changed with the introduction of a garage and filling station, but still retaining the name 'Bylands'. Behind the flint wall on the left, a field was the local football pitch, which saw many battles against neighbouring villages in the early 1900s. In the same theme, the field and its surrounding area now contain several soccer pitches, around a modern recreation centre.

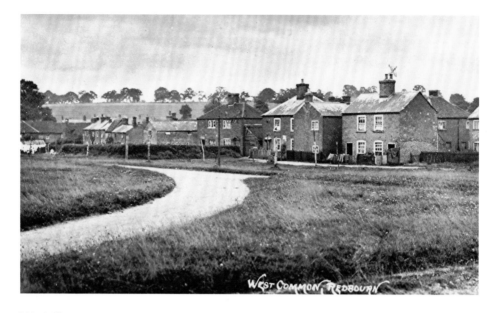

West Common

At the bottom of the Common is West Common, a line of red brick cottages, and one of flint. They stood at all angles, some behind others, as the photograph (*c.* 1920) shows. Old Redbourn families, such as the Taylors, Rolphs, Peacocks and Clarkes, raised their children from these cottages. In the far line of adjoining cottages lived Mrs. Gurney, a war widow in World War I. Trying to raise a young family was hard, but my father had seen a bough from the avenue on her fire. It protruded into the small room, and was pushed forward as the end burned. From one of the semi-detached houses in the centre of the row, Alice Rolph married Cyril Woods in 1931. 'Sep' Smith and 'Auntie' Maude lived in the partially obscured flint cottage on the right. The annual village fete in the 1930s saw 'Sep' as the supreme champion pillow fighter. Being a big man, seldom was he dislodged from the flimsy pole serving as a seat. Only three of the original row of cottages remain.

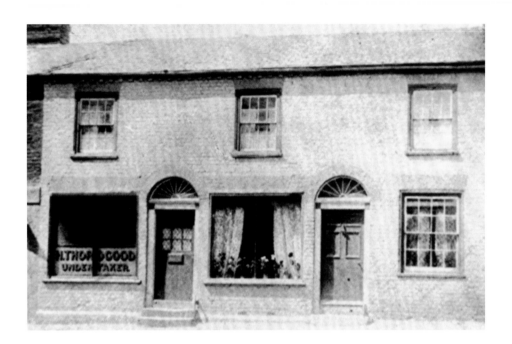

The Undertaker

At the top of the High Street, and opposite the turning to Harpenden, stood 'Friday' Thoroughgood's undertaking premises, (photo *c.* 1905). His sister, Mrs. 'Brinny' Quick lived higher up at North Place. So typical of the trade, he was never out of work! At that time his mode of funeral carriages were horse drawn, glass-sided carriages. In the 1930s, Mr. Whittaker opened the premises as a grocers shop, and very popular it proved. Often heard was the quote "I'm just going to pop up to Whittaker's." You would be served by the man himself dressed in his brown smock, collar and tie – pencil behind his ear. Later Miss Daines, small and stocky, always smiling, was the next proprietor. Lastly were the Fishers. Mrs. Fisher, always bustling, was pleasant and always obliging. As can be seen from the new photograph, it is now a private home. Actually their son John lives there, and he's called the house 'Whittakers'.

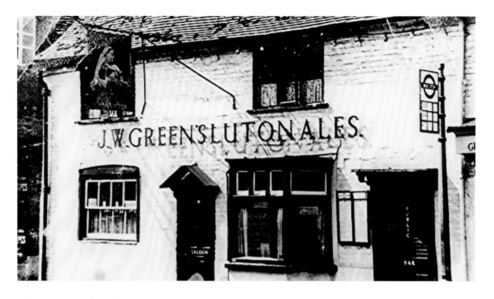

The Queen Victoria

Opposite the High Street Post Office was the Queen Victoria Public House, a hostelry much quieter than its television counterpart. Although Mr. Edwards wasn't a landlord with the happiest of natures, the pub was always busy and well supported. The Horticultural Society held its annual dinner here, as a photograph taken around 1948 shows. Well known villagers are represented around the table, such as the Elsoms, Dimmocks, Hobbs and Clarkes. By the table top, cigarette smoke and the drooping tulips in the vases, obviously a convivial evening was had by all. When delivering milk to the ever open back door, Mr. Edwards never smiled, but perhaps passed a mournful remark about the world situation, or the dull weather. Picking up the empties, I would beat a hasty retreat with "Shut the gate" ringing in my ears. After the pub closed in the mid 1950's, and following massive alterations , a small supermarket opened, which was later extended.

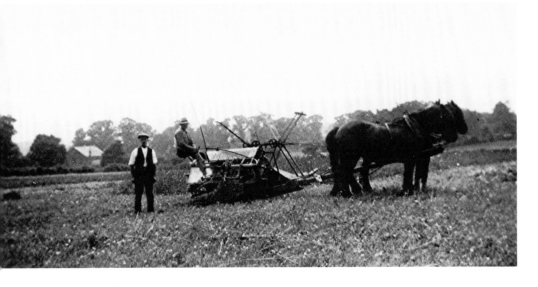

Cooper's Meadows

A path ran across the high part of Cooper's Meadows leading from Crouch Hall Lane to Lybury Lane. Jim Dayton is seen here following the binder, circa 1937. Note the Weslyan Chapel (now the Methodist Church) in the background at North Common. In the far distance is the old avenue of elm trees on the Common. To stand here now, in Long Cutt, one has the Junior School and Lords Meadow between to baulk the view. Such pastoral scenes are not possible today – combine harvesters have made the task much more efficient and quicker. Most of the meadow is now the playing field of the Junior School. It was not easy to get a similar angle to the old picture, especially with trees masking the school. Going to a friend who lives opposite the school, my wife and I explained the project in hand, and Margaret finished up standing on a bed to take the modern photo from a bedroom window! From this village high point, unbelievably, it was possible to see St. Albans Abbey, 4 ½ miles away – even the flag was flying.

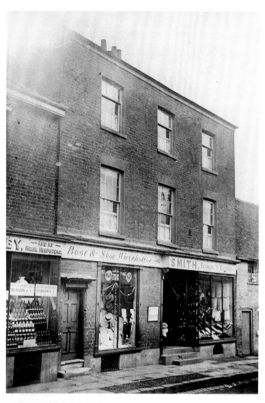

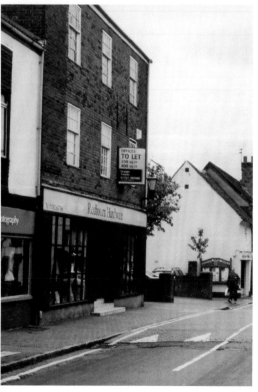

Smith's Shop

From the 1930s to after World War 2, Edward 'Chump' Smith, with his wife Lilian ran the general outfitters (photo *c.* 1920) next to the Public Hall (now the Village Hall). Mothers took their children to be measured for boots and shoes, and there was little that could not be purchased for a child! I remember seeing models of white and black children advertising and demonstrating liberty bodices! Edward's nickname certainly didn't reflect his character as he was well thought of in the village. He never seemed rushed, and took time and trouble to explain the usefulness of his wares. The house, with it's tall Georgian windows, had a few stories to tell. In the old coaching days it was used as overflow accommodation when the Bull Hotel was full. Looking at the ceiling, it was possible to see where a chandelier had hung in those halcyon days of travel.

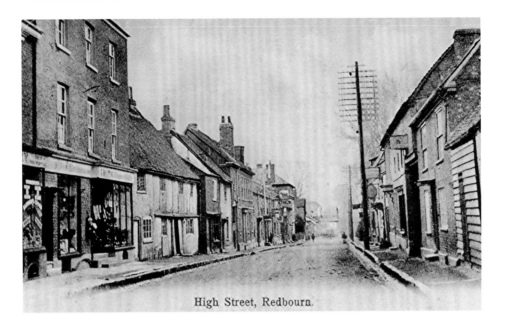

High Street, Redbourn.

Middle of the High Street

Looking south, the centre of the High Street looked like this circa 1905. On the right is the forge gateway. Many times I have led one of our horses through there for Bill Sibley to put on a set of new shoes. Just below it, where a circular board hangs, is the Tom in Bedlam Public House, which operated until the early 1900s. The Cowthard family were there at the time of closing, and daughter Phyll Austin has told me how, when an aeroplane had to make a forced landing at Church Fields, the pilot lodged at the pub. She explained that a picture was taken of him with her family outside in the High Street, but sadly the photograph was lost. The pub was converted into two shops – a greengrocers and a cobblers. Percy Hobbs was the shoe repairer, and the walls of his shop were covered in show certificates and awards for his champion green singing finches, which he bred in his back garden aviary. They were similar to siskins. Opposite is a little dark shop window, known affectionately as the 'Watch Shop', now a carpet shop.

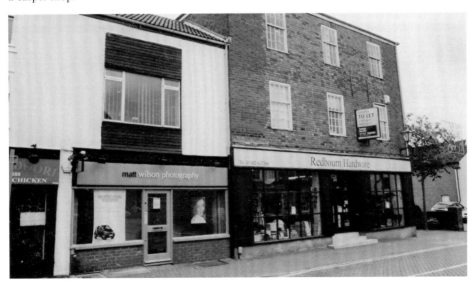

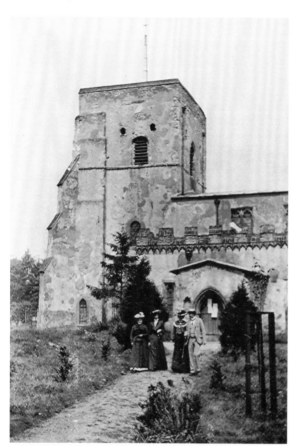

St. Mary's Church

Our Norman church in Hemel Hempstead Road, St. Mary's. appeared like this in 1901. This is a definite date as a young member of the Piper family seen leaving the church, gave it to me. The churchyard was quite unkempt. It wasn't so easy to keep cut in those days, as other pictures show how scythes were used to do the job. Around the late 1930s I was a member of the choir when the Reverend Birkhead Berry was nearing the time of retirement. His wife kept stern control of us by watching our every move in the mirror above her organ seat. In 1942 the Reverend David Bickerton arrived and stayed until 1952. In winter the church was kept reasonably warm by a huge coke stove, lovingly tended by the ever-present Charlie Stevens. Today the front of St. Mary's is dominated by a wide spreading, tall Lebanon Cedar, which has been drastically reduced due to storm damage, and old age. An attractive clock on the tower was given by the Womens Institute in memory of Gertrude Peake, its founder.

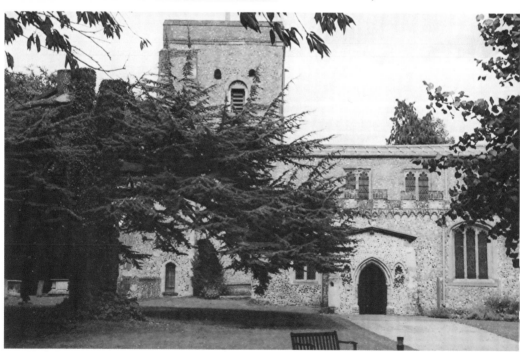

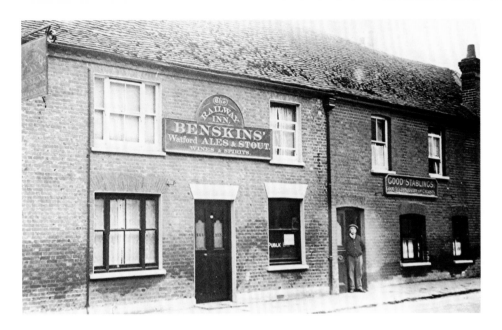

The Railway Inn

Opposite Russell Harborough's jam factory was The Railway Inn, aptly named as it was the first public house at the south end of the High Street, near the railway station. The picture, circa 1930, shows landlord Bill Mills standing at the door of this quite extensive property. Bill was a Boer War veteran – his white, walrus moustache so typified a military demeanour of that time. Bill and his wife Louise led a busy life. Coping with the needs of ten children, the organising of stabling horses in the outbuildings at the rear, which were accessed from Fish Street, and the running of the pub was a major task. When the snow and ice of the long, cold winter of 1947 eventually started to melt, flood water from the Common rushed down Fish Street into the yard of the Railway Inn. It quickly filled the cellar, then floated the carpets out through the front door into the High Street. Mr.& Mrs. Len East were the publicans then. Not long after this catastrophe the pub closed, and is now a row of smart homes.

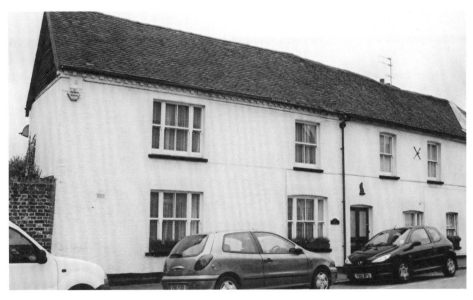

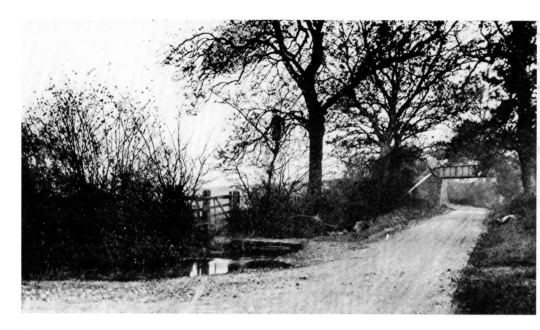

Chequers Lane

Chequers Lane led from the pub of the same name to the bottom of the Common, near the Moor. The old photograph (*c.* 1930) shows how a crosspath led to fields on the left, and to Fish Street Farm and the Common on the right. I have seen Joe Elsom return from ploughing in the fields at tea time, and wait patiently as his two shire horses cooled their feet, and slaked their thirst while standing in the river. As they looked up water drooled from their mouths – a lovely country scene. It was here that a mystery was solved. In the early 1900s a Church End boy suddenly disappeared. He wasn't seen for three weeks at the Boys School, or at home. Everyone asked "Have you seen Jimmy?" – until a lad said "I know where Jimmy is". All this time he had lived in a tree in Chequers Lane! This old view is probably the most altered in the village, with the railway bridge demolished and the bypass dominating.

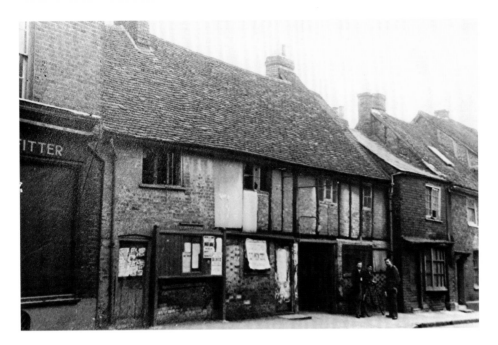

Cinema Alley

These London evacuee boys had probably been studying John Heather's notice advertising the films he would be showing on the following Friday evening in the Public Hall. When this picture was taken (1948) these cottages had reached the eventide of their lives. Shortly after they were demolished to provide a car park for the hall – but what stories went with them! Before the First World War, Freddie Boucher, the local dentist at the bottom of the High Street, showed silent films for the Redbourn youngsters, and my father played the piano to reflect pathos or action, whatever the moment required. The passage was called Cinema Alley. Freddie Boucher was the precursor of John Heather. Several families lived in this row including Stever Holt with his wife Rosanne, daughters Rose and Lizzie and son Charlie. These siblings were to spend the rest of their lives in Redbourn.

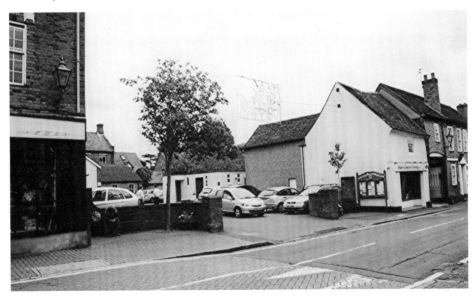

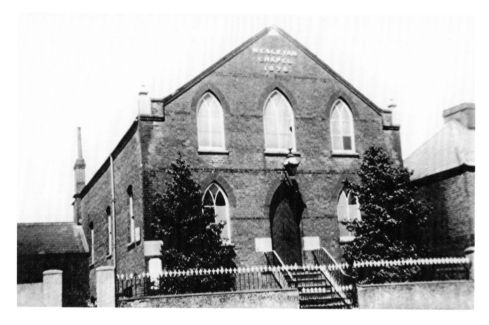

Methodist Church

The Wesleyan Methodist movement was strong in the village, with its headquarters at North Common. The original small chapel was soon found inadequate and, in 1876 the present building, nearer to Snatchup Cottages, was at the centre of the village on the Common. Prominent families such as the Anstees, Wards and Catlins did sterling work to help the chapel to flourish. Tom Pratt, a steward, was a great benefactor. In the late 1920s and into the '30s he would load Sunday School youngsters onto his horse and cart, and proceed for a picnic at Porridge Pot – a track off Harpenden Lane towards Harpendenbury. During the Second World War, Mr. Watts was headmaster of the London evacuees, and showed films to children on Saturday mornings. Yet another projectionist, so popular in those slightly solemn times, Freddie Boucher provided silent films before the First World War, and was a preacher at the Wesleyan Chapel. In more recent years, it is known as the Methodist Church.

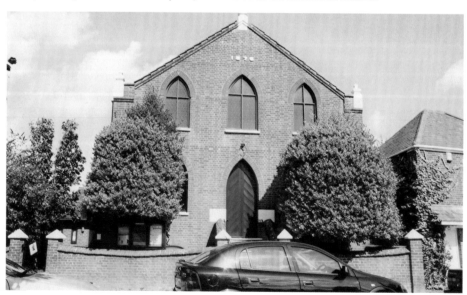

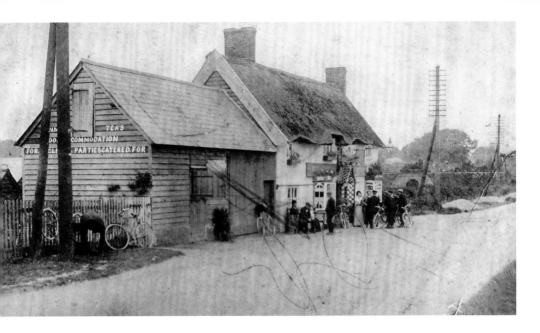

The Chequers

Approaching Redbourn on the St. Albans Road, there stands the Chequers Public House, on the corner of Chequers Lane. On the 7 June, 1908, a lad cycled out of the lane into a chauffeur driven car, and was instantly killed. *The Herts. Advertiser & St. Albans Times* produced a lengthy report of 'Redbourn's first motor fatality' including the following Court case. On the old photograph, X marks the spot. In the 1930s Bill Bridge used the black barn to sell antique furniture and bric-a-brac. Outside he stood a stuffed black bear in a menacing pose on its back legs. It became a celebrated village landmark, especially around the time Whipsnade Zoo opened in 1931. Some local lads moved it near to the railway bridge, leaning into a hedge, with its back to the road. With the rumour that "a bear has escaped from the zoo" parents panicked and kept their children indoors! On V.J. night, a celebration rocket completely burnt the thatched roof, and an over heated chimney had the same effect recently.

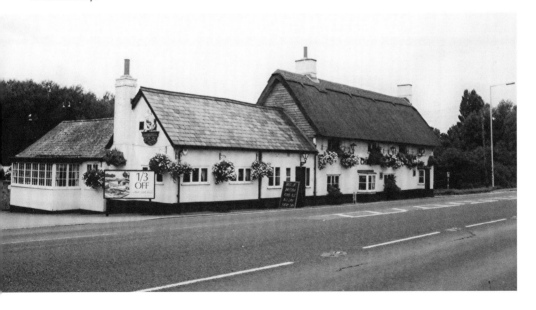

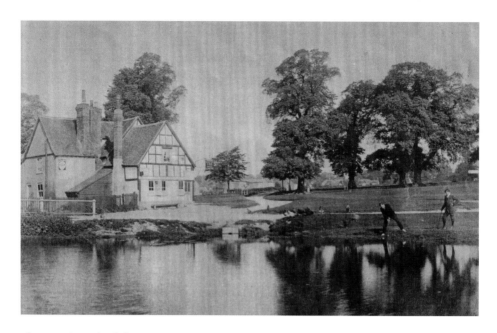

The South End of the Common

This delightful photograph (*c.* 1908) was taken by May Walker, our local pioneer of photography, and it shows The Jolly Gardeners Public House at the southern end of the Common. It depicts a typical rural scene with the chickens pecking freely, and Redbourn's celebrated avenue of elms. Redbourn Common accommodated a nine hole golf course at this time, as a coloured plan shows in 1906. May's brother Bert watches Dick Hillyard negotiate a difficult lie near the extensive waters of the Moor. Mrs. Taylor and her husband Alec ran the pub for many years, and their daughter Lily Reading carried on their good name. The pub was noted for its skittle alley, and good ale. Today it is a private home, the golf course has long gone, and the Moor is considerably smaller. With the present day volume of traffic, there is now no room for chickens!

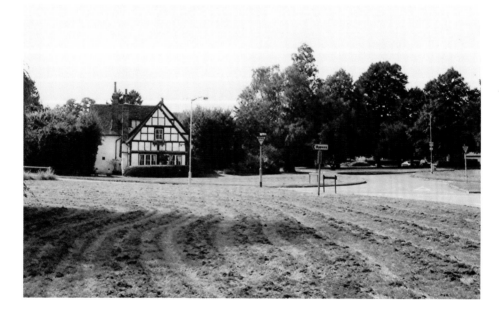

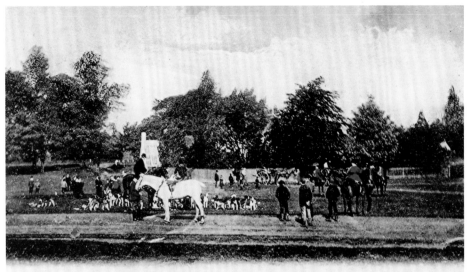

The Meet, Redbourn Common.

The Hunt

It has been a tradition now for many years for the Hunt to meet on the Common. Originally, the foxhounds with their red coated huntsmen – referred to as 'pinks' – would meet opposite the Boys School, now the site of the War Memorial, as a copy of a tinted postcard shows dated early 1900s. Later the Meet was held near the cricket pitch with the Aldenham Harriers as hosts in their green jackets with yellow collars; photograph 1963. Beagles were used for hare hunting as opposed to foxhounds. Stag hunting was organised on the Common towards the end of the nineteenth century, when an animal would be released and hunted in the surrounding fields. When one poor, exhausted beast returned and sought the safety of one of our cowsheds, one of my old ancestors stood her ground and refused the huntsmen access into our farmyard. The next morning the rested, and refreshed stag was given its liberty through the back fields. The traditional Meets have now been suspended from the village due to the actions of animal rights followers.

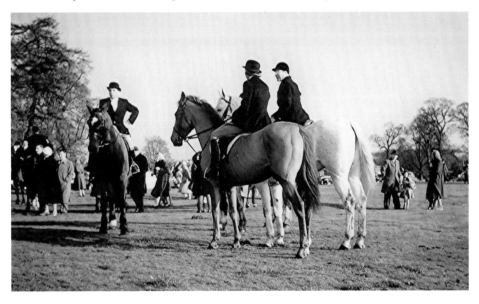

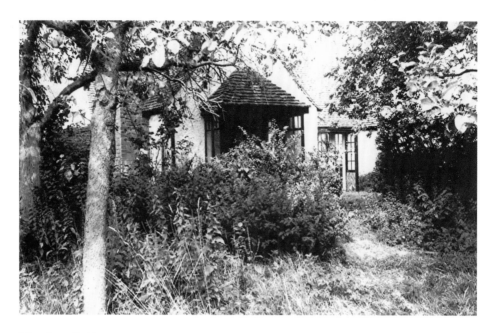

Meadow Cottage

Meadow Cottage is sited on the west side of the cricket pitch, well within reach of a hook or lofted drive over extra cover. Mr. C. V. H. Cooper came to the bungalow in 1927, because Miss Apthorpe was in residence at the Boys School house at the time. In a short while she moved in as companion to May Walker at Crouch Hall Lane, and the headmaster was able to take up his rightful abode. After the Second World War Mr. & Mrs. Tavener lived at Meadow Cottage with Mr. Tavener's sister; a very quiet family and well liked by all. A photograph shows the two sisters taking tea in the front garden with Sarah Quick from East Common. A typically peaceful Sunday afternoon. In the mid 1930s Mrs. Walkerly moved there from London. She was a retired soprano from the London stages, and caused quite a stir in the local concert party. Following various extensions, Meadow Cottage is still a very desirable residence.

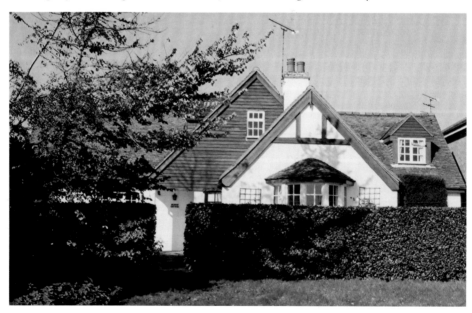

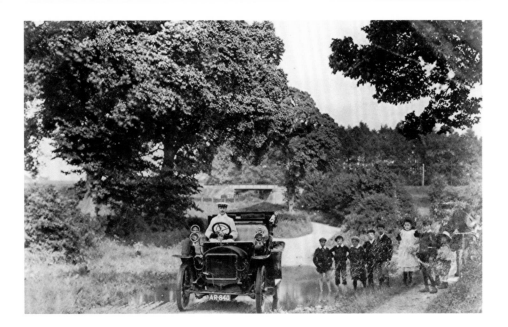

The Watersplash

Where the River Ver crossed Harpenden Lane at the bottom, it was known as 'The Watersplash'. This is a copy of a picture May Walker took circa 1910, showing the chauffeur driven car belonging to the Peake family being closely admired by a group of young car enthusiasts – cars were a rare sight at that time. In the background is the railway bridge on the Nickey Line from Harpenden to Boxmoor. Harpenden Lane continued past the bridge to form Harpenden hill, a natural 'dare' for early cyclists to hurtle down in an attempt to get through The Watersplash without stopping! How times have changed! The Nickey Line has gone – thanks to Dr. Beeching – and replaced by a path and cycle track. The whole area is traversed by the bypass, with an elevated roundabout. The River Ver now runs in a culvert under the lane.

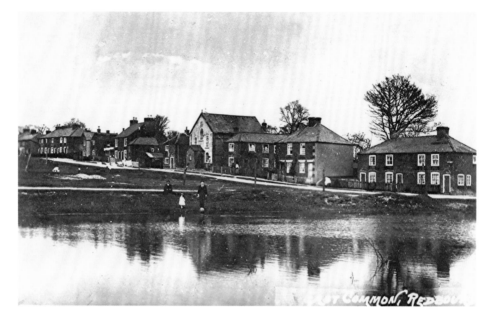

The Sheepwash

East Common, near The Moor, was the site allocated to several sufferers from the Irish Potato famine around 1895. They were allowed to erect a shelter for protection from the elements; hence some buildings today face in different directions. The Sheepwash Public House was part of the bottom three cottages, and The Moor was used by shepherds for just that purpose. Next to the Primitive Methodist Chapel is a cottage with a white framed front door. Emma Webb (not related to me) lived there. On the Common she would nurture little chicks in a coop with their broody mother. Emma kept a few geese that would swim on the Moor, and return home in single file at teatime. In a tiny house at the rear of the Chapel was Meggy Lee and his wife. Meggy was steeped in country life, and bred ferrets in hutches – sometimes. One morning, Dad stopped here on his round to accept a proffered cup of cocoa. When a ferret popped its head out of the arm of the horsehair sofa, Mrs. Lee explained that a pair were bringing up a family there!

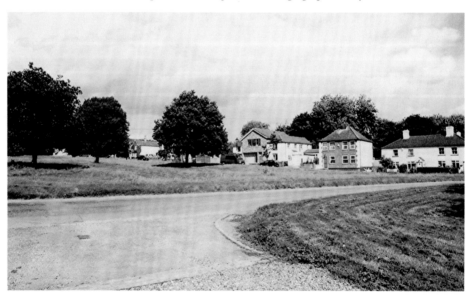

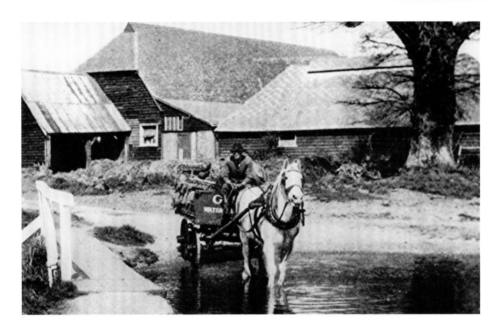

Redbournbury Farm

The River Ver ran through Redbournbury Farm when this picture was taken, *c.* 1930, when Charlie Weir was the farmer. Charlie took over farming here following the retirement of his father, William, who came from Scotland in the 1930s. Before that Mr. Weatherhead was the farmer. The river was a stronghold of the watercress industry in the area, and here we see George Lee having picked up his skips from the grower at that time, Bobby Vise. Charlie Weir welcomed the presence of my brother and uncle, with their air rifles with torches attached. At night they patrolled the sheds to keep down the prolific rat population. When switching on their torches one night, the rats beat a hasty retreat up the tree in the photograph. The trunk was caked in dry mud deposited by their feet. The bridge was a favourite place from which to catch 'tiddlers'. Some of the buildings have now been converted into office units, and the fields rented to a neighbouring farmer.

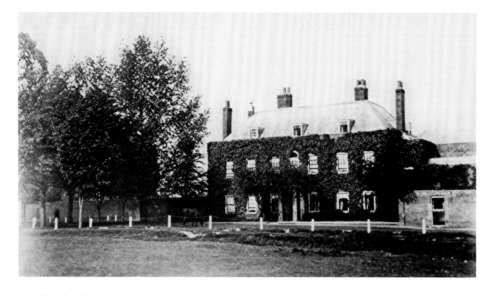

Cumberland House

Originally used as a hunting lodge by the Duke of Cumberland, the house was the home of Mr.& Mrs. William White in the 1800s. Cecil Peake, a mining engineer, and his family moved there from Staffordshire in the late 1890s, when this photograph was taken. The family was noted for its outstanding services to the village, especially by the two daughters, Gertrude and Anna. They were heavily involved with St. Mary's Church and the Womens Institute, and Gertrude was a Magistrate. Following the death of Cecil, the mother and daughters moved to The Heath on the Common in the 1930s. I was fortunate to have an enjoyable chat to a family member, who remembered coming to Cumberland House as a child, and never forgot the lavish hospitality. He also showed me an extensive family tree on vellum, superbly written in copper plate style, and complete with the family crest. Lady Wise followed the Peakes, a tiny person with a kind nature, and bubbly personality. The Central Electricity Generating Board purchased the home, and upon moving out, the grounds were built on, including a new Health Centre for the village.

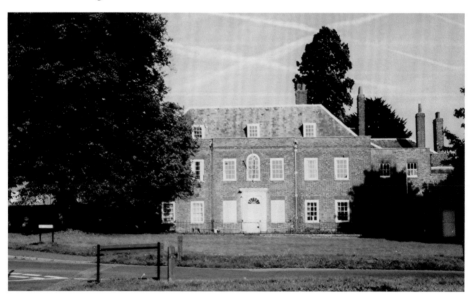

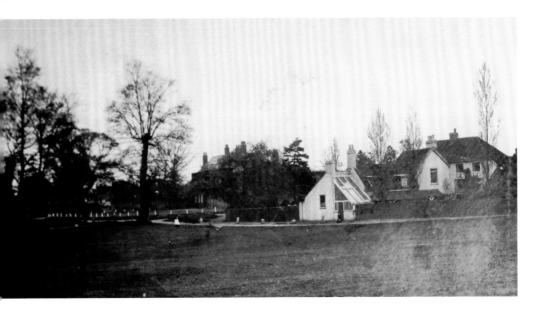

The Poplars – Greyfriars

Near the War Memorial, and facing up the Common is Greyfriars. Before the First World War it was called The Poplars (photo 1898), when the vicar, William Wade, was in residence. Shortly after the war, a new owner renamed it Greyfriars. Between it and Cumberland House is a pathway leading to the High Street and Doctor Totton's surgery. The Ruins was, and still is, a favourite cut through, but a bit spooky on a dark winter's night. In the 1930s, Captain Anstruther, a military man, was the owner of Greyfriars. He was a Home Guard officer in World War II. With our dairy just across the Common, I can remember early squads of home guard members on parade with broom sticks, before rifles were issued. The Captain was also a keen huntsman, a sport he encouraged his daughter Jean to follow. My father remembers how the screaming little girl, after falling off, was made to remount every time. Jean became a very proficient horsewoman. The Carmichael family were the next occupants, just after the war.

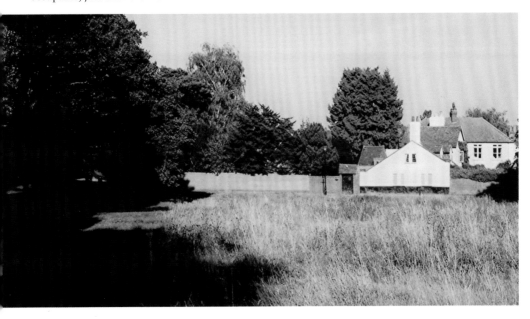

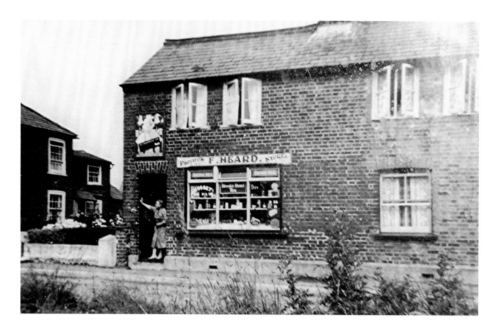

Heard's Shop

Flo Heard's shop (photo 1957) was the only one on East Common, and as it was directly behind the Infants and Girls Schools, it was well attended by school children for their sherbert dabs, pear drops and aniseed balls. The lady didn't suffer fools gladly, or for very long, and it helped if you knew what sweets you wanted before going into the shop. Gran Halsey's home was just below the shop, and it was to her I ran after school because she always had a selection of sticky sweets in a brown tin by the fireplace. In the 1930s, Bill Heard, Flo's husband, ran a popular fish and ship shop next door to his wife's shop. I watched fascinated, as he put each peeled potato between two iron jaws, and with a downward thrust of a long handle, forced the chips through the bottom into a bath, ready for the boiling fat. Flo's shop used to be the Gravestock's home, with their front room window used to display a few of their wares. Being strict Chapel people, the window was cleared each Saturday night for Sunday, and replenished on Monday morning.

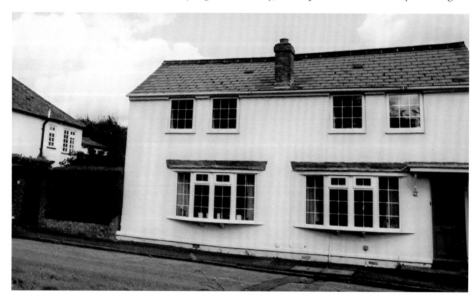

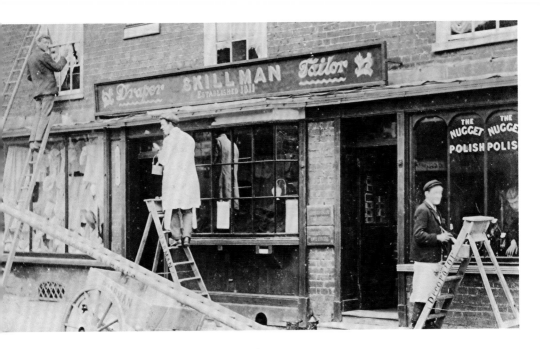

The Post Office

Sam Skillman's tailors and drapers High Street shop (photo *c.* 1914) was also the Post Office. This decorating job was one of the first ever for Percy Jarman when he set up his building business in 1914. At this time, the only transport for builders was a handcart for materials and ladders. As an apprentice, at a later date, my father-in-law has told me how he was sent to a job carrying a sheet of corrugated iron – on the bus! The Skillman family members were very versatile and accomplished musicians. The ladies were singers, while the men played various musical instruments. Min Jones and Jin Hall followed the Skillmans – this pair were real favourites. Jin's eyes weren't too good in later life for, when driving a friend to St. Albans, and approaching traffic lights, she leaned forward over the steering wheel enquiring "What colour are they now, Hilda?" It wasn't very long ago that I saw a cardboard box in the shop labelled 'Boys caps'. These modern decorators sportingly took up the positions of Percy and his men for the new picture.

East Common Bakehouse

The bakehouse at East Common was originally owned by the Dexter family, but in the 1930s Stan Brooke was the baker here (photo *c.* 1938), together with his bakehouse at Hemel Hempstead Road. Bill Quick was the roundsman with his horse and cart. He would come into the living room at the dairy and place his basket on the table while having a warm by the fire. The smell of new bread and doughnuts filled the room, and the crumbs and sugar that fell through the bottom of his basket had to be swept from the table. 'Shake' Thorogood was a short man, wore a flat cap, and he had small steel rimmed spectacles, little larger than damsons. Because he worked in the bakehouse, he had a permanent layer of flour all over him. He lived in the loft over the horse's stable. Bill's daughter, Laura, lived nearby, and when returning from afternoon school each day, she would collect a tiny cottage loaf made especially for her by 'Shake'. Eventually an artist bought the premises and opened a small gallery, but now it is a private home.

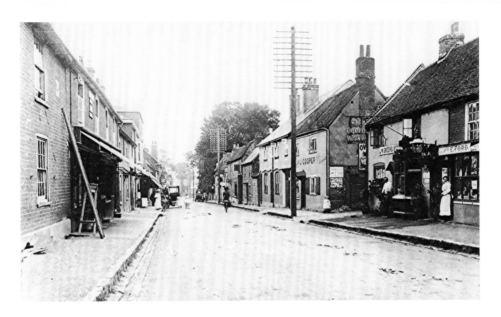

Ford's Shop

Next to the Queen Victoria Public House in the High Street was Edith Ford's grocery shop. In the picture, taken circa 1905, she stands at the door in her pristine while blouse and apron, waiting to cater for the needs of her next customer. Her daughter Violet continued the family connection several years later. In the 1930s Violet married Alan Partington, a north country lad, and they made an ideal couple to run the country store. It wasn't long before Alan joined the Fascist group, just before war broke out. He upset many locals when he attended meetings of the 'Brownshirts' in London. Although the couple seemed very happy, Violet must have experienced some uncomfortable moments. Next door, at this time, George Wilson was the well liked and respected chemist. His happy disposition always seemed to overcome the doubtful customer purchasing any remedy. Before moving to the village in his early years, George rode his horse from Flamstead each morning to the shop. Ford's shop is now incorporated with the Queen Victoria to form a small supermarket.

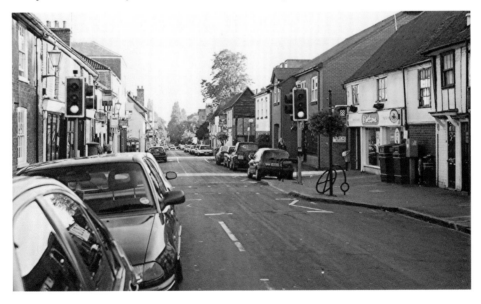

Luton Lane

In the photo, Minnie Hewitt and her daughters are obviously enjoying a walk near the River Ver at Luton Lane. Tommy Fox (in the photo *c.* 1930), married Mary who must have been taking the photograph. The Hewitt's home was behind the Boys' School at South Common. On Sunday evenings families would don their Sunday best clothes to go on a favourite walk around the village and meet other families, when the adults would put the world to rights, and the children would throw stones into the river, or study the field surfaces at ground level to detect the silhouettes of sitting lapwings, or peewits as they brooded their eggs. Mr. & Mrs. Fred Jackson lived in the cottage at the rear, on the road to Taylor's farm at Harpendenbury. It was on the fields of this farm, to the left of the picture, that at around Eastertime the point-to-point races were held. Fred Miles, the area champion hedge layer and thatcher, was responsible for building the jumps, his water jump on the River Ver was a masterpiece. The races were a highlight of the village calendar. This area of the old photograph now contains stables and a golf club.

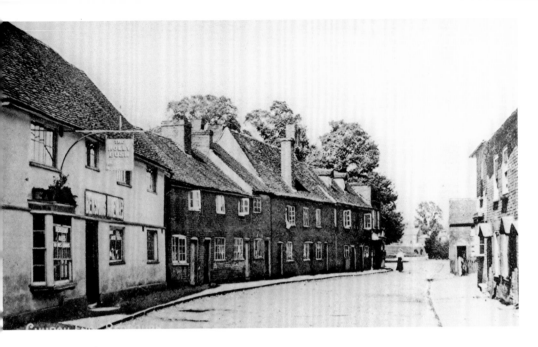

Church End

The Hollybush Public House in Church End is one of the oldest remaining pubs in the village (photo *c.* 1920). It is still very popular and has a regular 'clientele', so much so that, a few years ago, if a stranger sat in a regular's chair, they were asked to move! In the late 1930s the cottages next door were demolished. One of them was the home of Sammy Harrison, who grazed his donkey on the Common. To reach its stable at night, Sammy had to take the donkey through the house! The end property on the left was Joseph Darvell's grocers shop, so expertly carried on by his daughter, Olive, until after the Second World War, when it became a private house. The open door opposite the shop belonged to Mailings Bakery. Memories of old Church End residents recall the quality of its doughnuts. Today this is a quiet byway to the church.

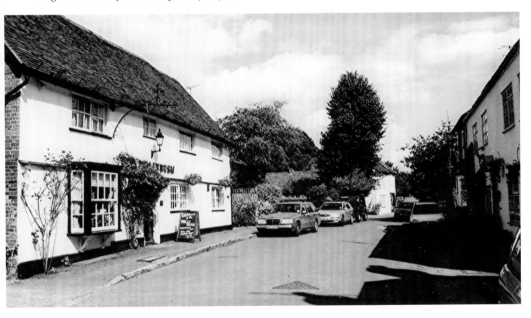

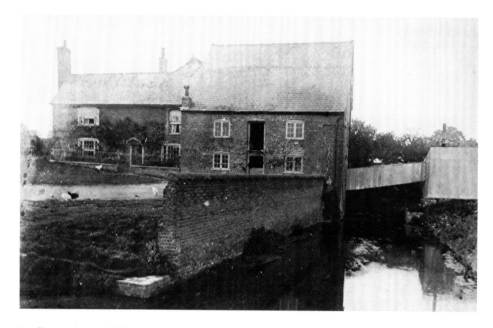

Redbournbury Mill

In an idyllic rural setting, Redbournbury Mill (photo *c.* 1915), was where farmers with horses and carts took their corn to be ground. Although standing on the River Ver, fluctuating water levels called for a steam engine to drive the stones. Even to this day, a diesel engine has been installed to overcome the same problem. Until the 1930s, Henry and Louise Hawkins were the millers, and daughter Ivy took over from them. Ivy was short and stocky, but a tough character. In 1959 May Walker produced pictures of her tending the stones and general work in the mill, such as hauling sacks. In the early days villagers were allowed into finished harvest fields to collect loose ears of corn – this was called 'gleaning'. These sackfuls were taken to Ivy who produced the flour or corn for chickens, for a few pence. The James family carried on the tradition, but fire ravaged the mill in 1987. With help from English Heritage the mill has been restored, and is now open to visitors.

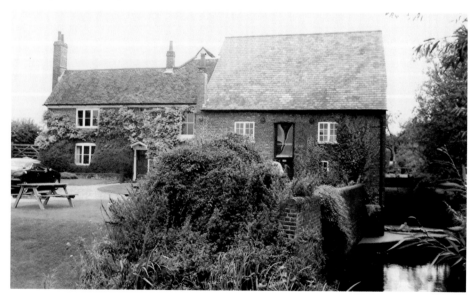

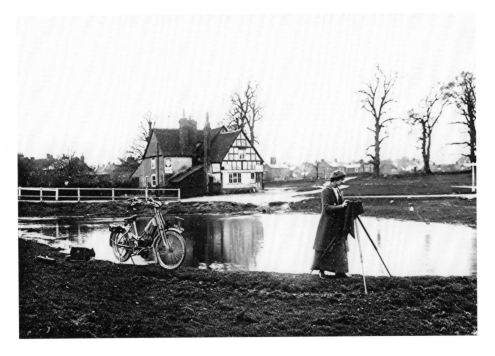

May Walker at the Moor

Among my Redbourn photograph collection, numbering well over 4,000, I am privileged
to include examples of May Walker's photographic expertise. She really was the pioneer of
photography locally, and this picture shows her near the Moor at the bottom of the Common
(*c.* 1910). Two of her earliest pictures are of Jim Dayton scything in a harvest field, and on
a roadside verge. Another of May's interests was motorcycles. Again, photographs show the
various models she owned over the years – some even have wicker sidecars. Her manly nature
was often tempered with a soft smile. She had a strong feeling for Redbourn and its history, as
her book entitled *Redbourn*, published in 1960 shows. Following a visit to the printers, her
car was involved in a slight knock on the Ancient Briton crossroads in St. Albans. May lost her
life at the scene from a heart attack, it is thought.

The Primitive Chapel

The Primitive Chapel at East Common was yet another branch of the local Wesleyan Methodists. Although quite small, it did possess a gallery. My grandfather Halsey's brother, Israel, was a shepherd and lived close by the chapel. He would certainly have witnessed the fire and brimstone sermons of George 'Tizzly Wizzly' Draper in the 1920s and '30s. George was a market gardener and relied on the elements to swell his cabbages and cauliflowers. More than once in his wailing prayers, he implores the Lord to send us a good rain "…. Not that tizzly wizzly sort!" George Anstee, who lived over the water at the Moor was a leading member of the congregation. When the chapel united with the headquarters at North Common in 1939, his son Harold changed allegiance and became a devoted member there. The chapel site, eventually, was used for a private home, at the moment in a state of renovation.

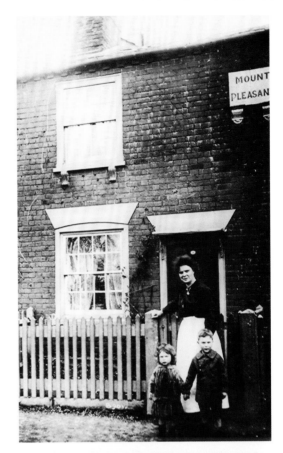

Mrs Luck

Mount Pleasant is a row of cottages next to the bakehouse at East Common. Florence Luck (seen here *c.* 1918) lived at No. 14 with her little ones, Florence and Reg. Doris, the elder daughter was annoyed to have missed the photograph as she was confined to bed with measles. At this time Florence was a war widow as Reg, her husband had lost his life in the trenches of France. This was doubly tragic for the families as his brother Fred also was killed there. In later life young Reg, nicknamed 'Wobbler', was a baker's roundsman, and his happy personality made him popular with everyone. Eventually he emigrated to Australia, and towards the end of his life, Reg came back to the village on holiday – more of a pilgrimage, it seemed. He was seen walking in all the old haunts of his childhood, as if he knew this was his last chance. Within a month or two of returning down under, Reg passed away. Florence, his mother moved further down East Common, near Gran Halsey, and was a devout member of the Salvation Army for many years, until her death in 1959.

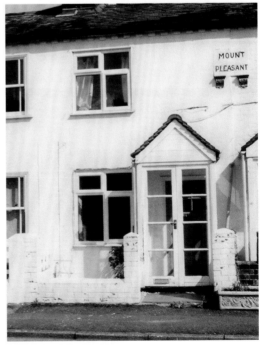

Girls and Infants Schools

These were Church of England schools, and were found between East Common and the cricket pitch. The Girls School, (picture *c.* 1905) was near the caretaker's cottage. Behind the girls class building, by the fir tree, was the Infants classroom, all part of the walled complex. An early caretaker was Emma Archer who lived in the cottage with her husband Arthur. Later Edie and Horace Fox lived there. One of the first Heads for the girls was Mrs. Harvey, wife of Charles Harvey, Headmaster of the Boys School. Later it was Miss Boggan, and Mrs. Cunningham, whose husband lost his life when the Ark Royal aircraft carrier was sunk in the Second World War. Miss Matthews was the strict Head of the infants in the 1930s – a world of coloured sticks, chalk and plasticine. She lived with her sister and mother at Harpenden Lane. Miss Humm, a friend to all pupils, came just before the war, and stayed until her retirement. The last girls Head was Miss Stocks; such a lovely disposition, with sadness shown by villagers upon her retirement in 1968. The Common was always the playground, and it saw a Maypole erected in the 1920s. Empire Day and Ascension Day were celebrated with half-day holidays from school.

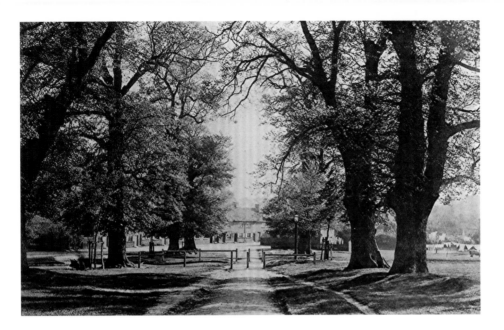

Bottom of the Avenue

Our avenue of elms (seen here *c.* 1925) was a noted landmark of the area, until its decimation from Dutch Elm disease in the early 1950s. The bottom trees ran to Church End, leading to St. Mary's Church. The railings were prime targets for a quick pirouette over the top bar by children on their way to school. To the right is West Common which, this sunny morning, has brought out washing onto the communal washing line posts, as could be seen then around parts of the Common. The horse feeding also illustrates the grazing rights of villagers for their livestock. In 1916 a violent gale blew down 19 trees in 15 minutes. The modern photograph shows how the new avenue of limes has matured into a magnificent replacement for the elms. In the springtime, the scent from the lime flowers can be quite overpowering.

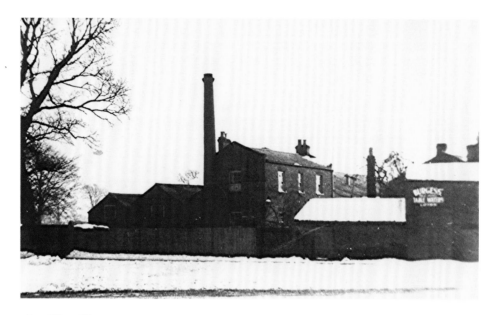

The Silk Mill

On this snowy winter's day, *c.* 1925, the dark slightly foreboding Silk Mill overlooked the Common from behind The Cricketers Public House. It provided considerable employment for the village, even employing school children, thus causing friction with school administrators! Written by the names of some pupils in the schools' admissions registers, (mainly girls), is the word 'removed'. This meant the child had left school at the early age of twelve. The Silk Mill meadow at the side of the factory was the home of Redbourn Football Club in the 1930s, where this successful team won many trophies, and was dominant in the area. Brooke Bond Oxo took over the empty property during the Second World War, at the time of the London blitz. Joe Windsor, the acting manager, and his family moved into the Mill house. Soon the old mill was demolished and several extensive new sheds appeared, until the site was full. Requiring more premises, Brooke Bond Oxo moved the Redbourn section to Manchester, but not before refurbishing the Mill House, and generously presenting it to the village as a home for the museum. This opened in the year 2000.

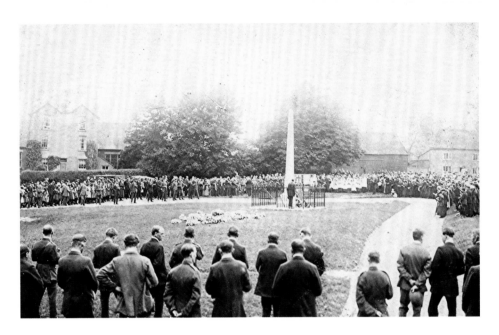

The War Memorial

The War Memorial was unveiled in 1923, and as can be seen, the service was well attended by the church choir, servicemen and residents, some of them mourning lost loved ones. It is noticeable how small the area was which was enclosed by the railings. The superb condition of the Memorial now is due to the dedicated hard work of James Millars. In the background, on the left, is the Boys School. At the time of the old photograph Joseph 'Joby' Laxton was the Headmaster. He was an accomplished organist, a bee keeper and a strict disciplinarian. He was followed, in 1927 by C.V.H. Cooper, a good teacher and sportsman. He encouraged football and cricket, and perhaps his 'dream come true' was when Albert 'Tony' Day was selected as a schoolboy international footballer against Ireland in 1934. The school was closed in 1959 following a short reign as Head by Leonard Stratton. It is now used for pre-school toddlers.

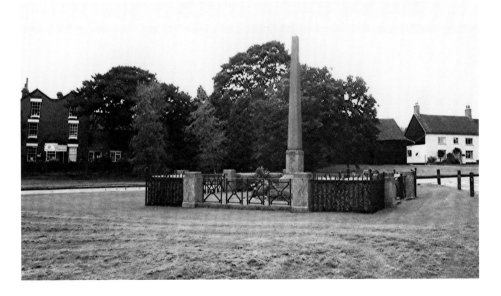

South Common

The low building, photo *c.* 1950, at South Common near the War Memorial, was purpose built at the beginning of World War Two as a nursery. Working mothers would leave their children to be cared for by seniors, such as Win James, helped by juniors like Beryl Reading, Betty Winch and Yvonne Anderson. Later Miss Humm supervised the Infants School children there. The Annexe, as it was known, was then used as a youth club. Close by is the gable ended Scout Hut, where local lads – now adults – enjoyed the usual scouting activities, not to mention boisterous games of duster hockey and British Bulldog. In the 1930s, Stan Blunt had the task of Scoutmaster, followed by the Rev. David Bickerton, Bernard Moore and Ron Dunham. The path between the buildings led through into The Park – it was a park then – to Chequers Lane and the fields beyond. Today the Scout Hut has gone – the boys have a different building at another location, and The Annexe is to be converted into a community building.

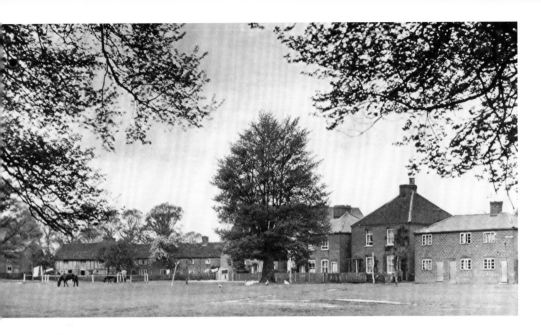

North Common

What a change North Common has gone through! Around 1910, communal washing line posts are plain to see, as are Harold Cooper's horses happily grazing. The cottages on the right housed the Gurney and Day families. The Gurneys lost their father in the First World War, thus making life hard for the mother to bring up a young family. Our dairy was on the opposite side of the Common, and when the children asked mother if they could have the gas light on to ease the winter gloom, mother looked across to us. "No, the Webbs haven't got theirs on yet!" Katy Day was short, plump and red faced. To call her children in for tea, she shattered the peace of the Common when bellowing 'Albert!'. We would jump out of our skins, but Albert always arrived. Albert was a gifted young footballer, and was to become a schoolboy international, finally joining the Tottenham Hotspur Football Club. The Second World War came along, and with Albert receiving a bad war injury, his career was jeopardised. Large parts of North Common have gone, but many happy memories remain.

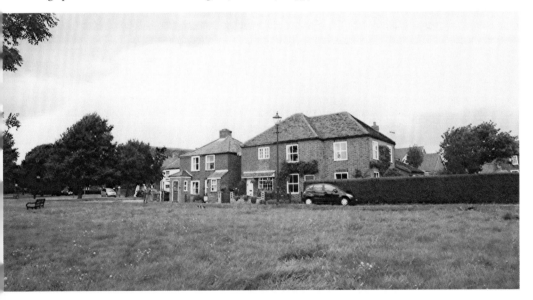

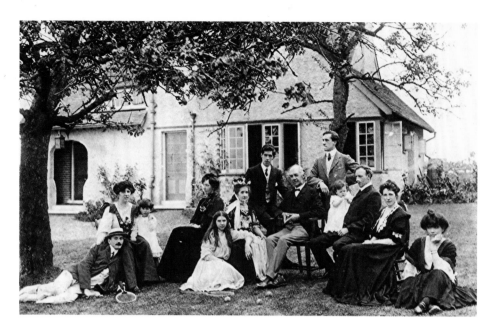

The Piper Family

'Hillbury', on the Dunstable Road, near Blackhorse Lane, was built for Thomas Piper, and made a lovely setting for this typically Victorian picture of the family in 1908. Other members had homes built in the village, one of which in Blackhorse Lane burned down. As a family with musical talents, and being connected by marriage to the Skillmans, enabled this group to make a considerable contribution to Mrs. Hunt's orchestra at Redbourn House in the early 1900s. One of the Pipers was a wanderer, and seldom seen at home. Franco was a proficient banjo player, and performed on the stages of variety theatres. A photograph, circa 1920, shows Franco and his assistant standing in a circle of sixteen spinning banjos. Miraculously, he managed to get a tune from the turning instruments. Although most of his engagements were abroad, it was still a surprise for local Boer War soldiers to meet him in South Africa at that time. Marjorie Boarer and her friends kindly posed for the modern picture.

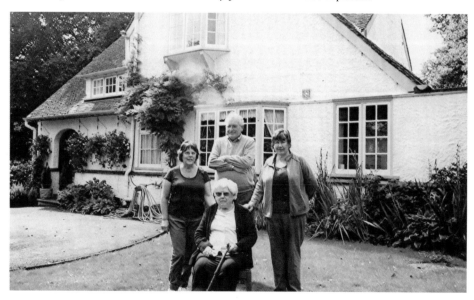

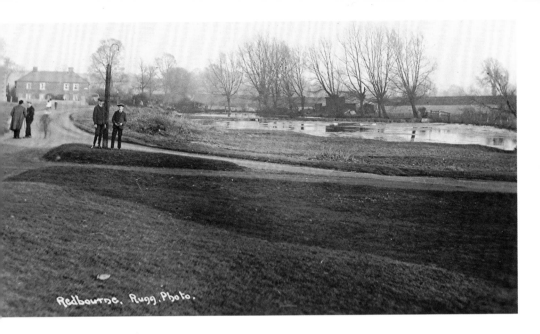

Redbourne. Rugg. Photo.

The Moor

The expanse of water at the bottom of the Common was always known as The Moor. (photo *c.* 1925). The only dwelling on the right belonged to George Anstee, a prominent figure in the Primitive Chapel at East Common. To reach it he used a track that bisected The Moor. The track continued over the railway line to Dane End, a favourite Sunday evening walk. Looking towards East Common and Chequers Lane, it is noticeable that the River Red, flowing underground at the side of Hemel Hempstead Road, made a considerable contribution. The Moor was the village paddling pool. Children sailed their toy boats, and caught minnows and sticklebacks in their fishing nets. Jam jars with water and a bit of weed made interesting windows on pond life, with their tadpoles, newts and fish. As the modern picture shows, the water has been reduced behind the attractive landscaping of willows. Houses border The Moor now, well into Chequers Lane.

Top of East Common

East Common was a quiet road when this photograph was taken around 1950. The low gabled building, known as the Club Room, was used for various functions, such as dinners and wedding receptions. Redbourn Football Club held its annual dinners here, and my father has told me how he remembered a young, gifted footballer and a legend in the club, being lifted from the room, paralytic – a new experience for him. Drink was to blight the rest of his life, such a waste of talent and degradation for a popular and talented character. Photographs from the 1920's show happy wedding groups having their pictures taken outside, on the Common. Several East Common families used the facility on such occasions. Behind the houses, Brooke Bond Oxo was expanding at a rapid rate, and needed a new entrance for their large lorries. The Club Room and the house next door were demolished to accommodate that requirement. Although essential, the motorcar has transformed many residential localities, as the modern photograph illustrates.

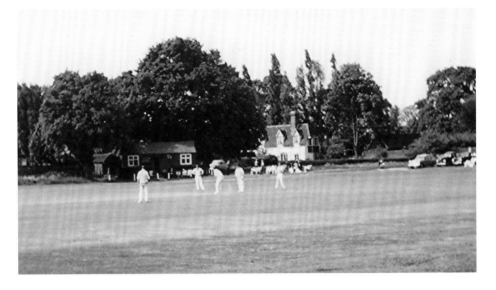

Cricket Pavilions

The cricket pavilion erected on the north end of the pitch in 1932, (photograph *c.* 1965) must have been a splendid addition for the club, after the preceding small marquee. At the time of the first basic changing facilities, Redbourn Cricket Club won the Herts. County Cricket Club Challenge Cup in 1888. Winning it again for the next two years gave the club outright ownership of the trophy. In the 1920s and '30s, cricket teams here were always noted for outstanding talent by the opposition. In the 1930s, Flamsteadbury Farm gave the club a heavy roller, originally pulled by a horse. Over the years the shafts became loose, and were replaced by an iron frame. The old pavilion was the chosen site when the Earl of Verulam handed over the ownership of the Common to the village. Leading councillors and other notables accepted this special gift on behalf of Redbourn. In 1966 a new pavilion was built diagonally opposite the old one. The much superior building had larger changing rooms and a bar. This pavilion was updated in 2007/8, and behind it can be seen the old roller. It has now been replaced by a motorised roller.

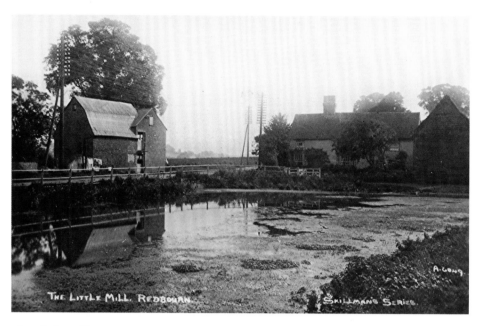

THE LITTLE MILL. REDBOURN. SKILLMAN'S SERIES. A.LONG

The Little Mill

The Dolittle Mill, on the left in the photograph, circa 1915, stood on the St. Albans Road where the river Ver passed under. It was a smaller mill than the one at Redbournbury, but was closer to the village. On the other side of the road stands the mill house, an attractive property that used to border a large expanse of water. In a cottage nearby, during the early 1920s, lived Fred 'Wimmy' Hoar, a country character with a wicked sense of humour. Part of Fred's work at the mill was to 'dress' the stones. He would clean and sharpen the grooves in the mill stones, to ensure a constant flow of flour. In 1913, Fred married Dora Reed, and photographs show the wedding group to the right of the picture with the mill in the background. The bridesmaids hold large baskets of flowers. In the group is Dora's elderly father, Bert 'Turp' Reed, who also worked at the mill. Today the mill has gone, and the mill house no longer stands near the water. Much has been grassed over, and outbuildings converted.

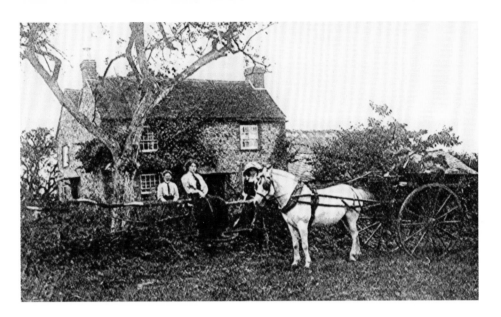

Crouch Hall Farm

The old Crouch Hall Farm, picture 1914/15, was at the top of Crouch Hall Lane, and surrounded by small fields. In the photograph are William and Eliza Hall with their family. William had retired from the Metropolitan Police at Enfield, and had moved to the farm, probably in search of a quieter existence. In the first quarter of the twentieth century, George Selmes, a veterinarian, lived at the farm, and was responsible for the local pack of foxhounds. In the outbuildings of the present property is an ancient window with iron bars over the window panes – quite possibly the kennels for the dogs. I remember Cyril Harvey as the occupant, a perky military type, so aptly shown when leading Home Guard parades as an officer on Armistice Day. Today, much building has been completed around the farm, and Dr. Nejad's wife Elizabeth kindly posed with daughter Charlotte and her friend Tanya.

The Holt's Home

At the bottom of Crouch Hall Lane, where it joins Lamb Lane, is the old home of one of Redbourn's notable families of that time, (photo. *c.* 1930). William and Jane Holt lived here in the first quarter of the twentieth century, after which their son Ted and his wife Annie succeeded until the Second World War. In the picture Annie stands with daughter Laura. Ted used the field at the rear for his trade as a knacker, when he brought old horses and cows before they went to the abattoir. Laura and her sisters, together with their husbands, were keen members of the Auxiliary Fire Service set up in the village at the beginning of the Second World War. In more recent years the vacated home was used as a doctor's surgery where the jovial Scot, Dr. Lindsey Miller dispensed his expertise. Finally, the house has reverted to its initial purpose, as a private home.

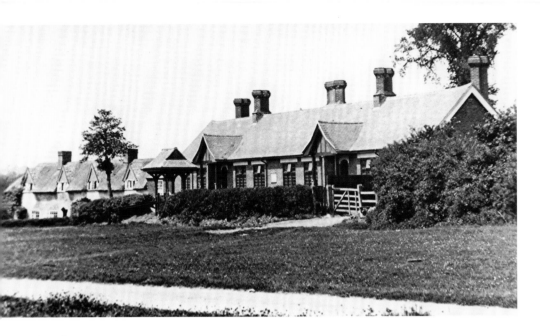

The Alms Houses

These four alms houses, photograph circa 1925, are sited on the south west end of the Common and were built at about the time the old picture was taken. The Woollam family was responsible for this gift to the village, and it was Charles Woollam who was one of the early managers of the Silk Mill. What a nice way to live out one's final years. These deserving people were able to walk onto the Common, or tend their small gardens, but generally enjoy the summer sunshine. I delivered milk to these residents, and I walked in to most of these homes and put the milk on the table, and, when settling their small accounts on a Saturday, they loved to talk over old times. Miss Silsby, a member of a family that lived next to Harry Harborough on the corner of Waterend Lane, lived in the right hand one of the four. She was very tiny, a really gentle lady, and I always studied her weather house on the wall, to see if the woman or the man was out.

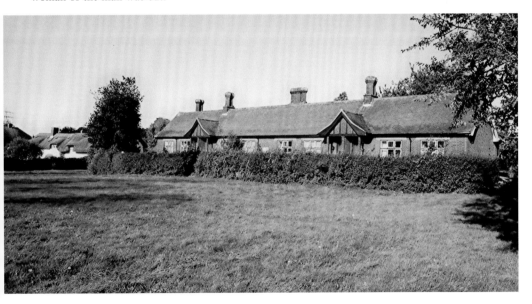

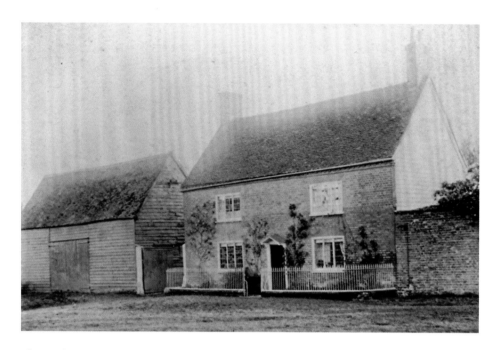

The Dairy Farm

The dairy was quite close to the War Memorial (photo *c.* 1880), and it was at about this time that our family provided the village with milk. I was born here, a third generation son, and was privileged to have had such a close relationship with most of the villagers. Of course, the stories are numerous that illustrate our lives, and those of our ancestors. One of them actually worked on the mail coaches, and lost his life in a horrendous accident. The family still has in its possession a watch that was used on the mail journeys to time the duration of each stage. During the Second World War, two London evacuee boys lived at the dairy with us. Try to imagine the anxiety when taken from their East End homes and left at a village in Hertfordshire. Billy always acted slightly superior to poor Walter, but the latter could always refer to Billy's habit of wetting the bed! Recently, the dairy has seen many changes, and is now divided into private homes.

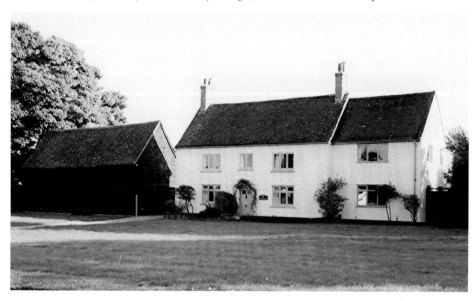

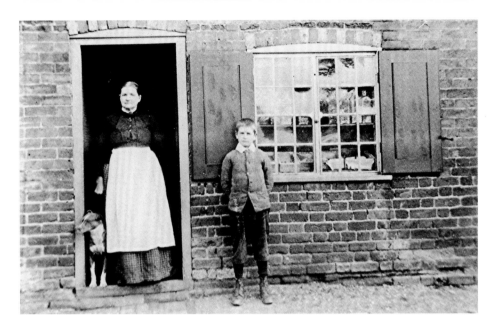

No. 8 Church End

I have never met anyone who could remember a sweet shop at this number. Although the original photograph was taken circa 1860, there are no records of when the shop closed. Tom Catlin was a prominent Methodist Church worker in the second half of the twentieth century, and this is his great grandmother standing in the doorway. His uncle, as a lad, is by the window. John & Suzy Lough are now the occupants, and Suzy with son Guy kindly posed for the modern picture. I remember Tom's mother, Emma, living at the same address. More recently it became the home of Lois Hinton, a local school teacher who retired to this cottage. Lois will be happily remembered by many children who experienced her teaching qualities and mild nature. She was a notable Girl Guide leader, and it was also her ambitious brainwave to start a museum in the village. After several years, the present museum is a testament to Lois's inspirational idea.

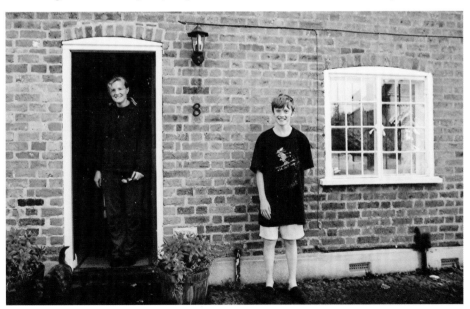